BEAUTY FROM THE EARTH

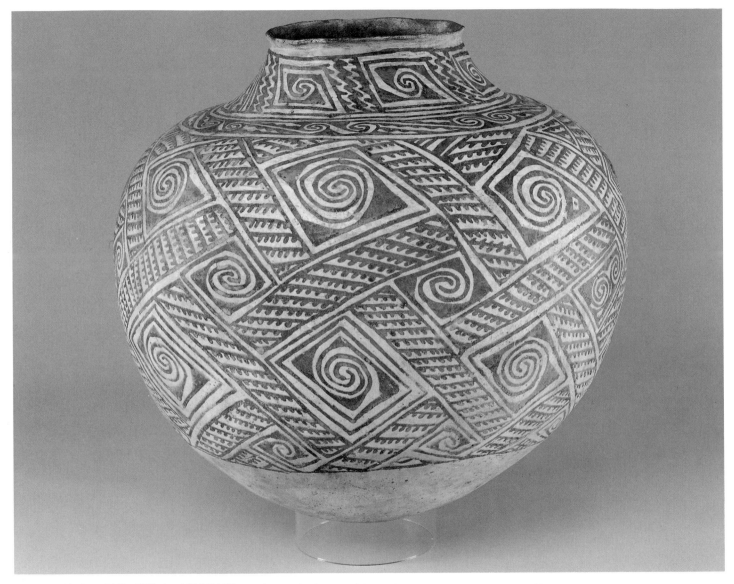

P L A T E 1. JAR (Olla), ANASAZI, *Walnut Black-on-white, circa A.D. 1100–1125. Collected by Stewart Culin on the Wanamaker Expedition of 1901. H. 43.0 D. 44.0 cm (29-77-686). This pottery type resembles Flagstaff Black-on-white (compare with Cat. No. 16), and both came from the region where Hohokam, Mogollon, Anasazi, and other ancient southwesterners came together. (Cat. No. 15)*

BEAUTY
FROM THE
EARTH

PUEBLO INDIAN POTTERY FROM THE UNIVERSITY MUSEUM
OF ARCHAEOLOGY AND ANTHROPOLOGY

J. J. Brody

with a brief essay by
Rebecca Allen

The University Museum of Archaeology and Anthropology, University of Pennsylvania, Philadelphia, Pennsylvania 19104-6324

Library of Congress Cataloging-in-Publication Data:

University of Pennsylvania. University Museum of Archaeology and
Anthropology.
Beauty from the Earth: Pueblo Indian pottery from The University
Museum of Archaeology and Anthropology / J.J. Brody,
Rebecca Allen. p. cm.
Includes bibliographical references.
ISBN 0-924171-05-7
1. Pueblo Indians—Pottery—Exhibitions. 2. Pueblo Indians—
Antiquities—Exhibitions. 3. Southwest, New—Antiquities—
Exhibitions. 4. University of Pennsylvania. University Museum of
Archaeology and Anthropology.—Exhibitions.
I. Brody, J. J. II. Allen, Rebecca. III. Title.
E99.P99055 1990
979'.01—dc20 90-47387
 CIP

Front Cover: "Ruins in Mummy Cave Canon del Muerte, Ariz." Photograph by John K.
Hillers, circa 1872–1879 (neg. S4-139877). Hopi Bowl, Cat. No. 59 (neg. 29-77-725).

Back Cover: "Ancient Ruins in the Canon de Chelle, N.M." Photograph by Timothy H.
O'Sullivan, 1873 (neg. S8-139868), Laguna Polychrome Jar, Cat. No. 86 (45-15-103);
Sikyatki Bowl, Cat. No. 52 (39051); Anasazi Jar, Cat. No. 15 (29-77-686).

Photographs of specimens from the Collection by Fred Schoch

Book Design by Dennis Roberts

Typography: Interior typeset in Leawood Book by
Science Press, Ephrata, Pennsylvania.

Cover display type set in Tasman Bold, Avant Garde by
The Composing Room, Philadelphia, Pennsylvania.

Printed by Science Press, Ephrata, Pennsylvania.

This catalogue and the exhibit "Beauty from the Earth: Pueblo Indian Pottery from
The University Museum of Archaeology and Anthropology" were made possible, in part,
by generous grants from the National Endowment for the Arts and The Pew Charitable Trusts.

Publications Department, The University Museum
of Archaeology and Anthropology
33rd and Spruce Streets • Philadelphia, Pennsylvania 19104

TABLE OF CONTENTS

PREFACE page ix
 Robert H. Dyson, Jr.

INTRODUCTION AND ACKNOWLEDGMENTS x
 J. J. Brody

LIST OF COLOR PLATES vii

LIST OF FIGURES viii

MAP OF FOUR CORNERS AREA xii

BEAUTY FROM THE EARTH 1
 J. J. Brody

POTTERY TECHNOLOGY 57
 J. J. Brody

THE HISTORY OF THE UNIVERSITY MUSEUM'S
 SOUTHWESTERN POTTERY COLLECTION 61
 Rebecca Allen

CATALOGUE COMPENDIUM 89

CONTRIBUTORS 100

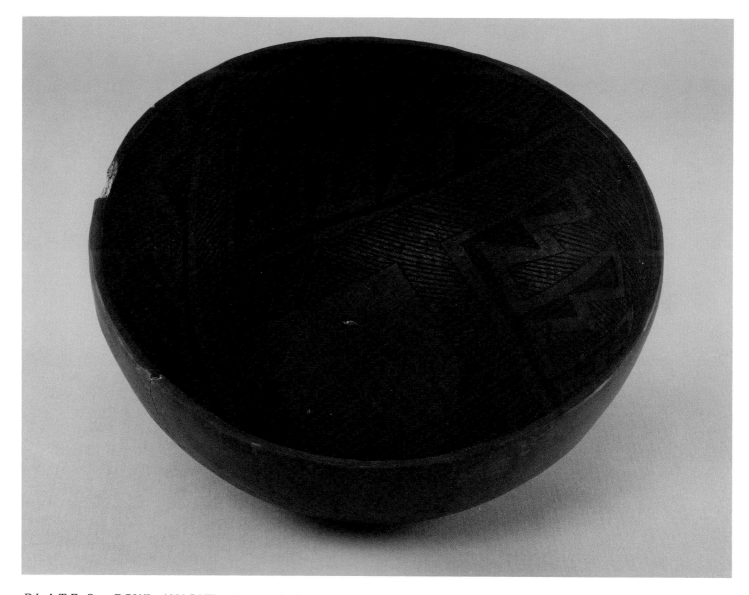

PLATE 2. BOWL, ANASAZI, *Wingate Black-on-red, circa A.D. 1050–1200. Collected by Stewart Culin on the Wanamaker Expedition of 1901. H. 11.0 D. 26.2 cm (29-77-599). This bowl comes from the Mogollon-Anasazi border region and has an Anasazi-inspired design. The interplay of hachured and solid painted areas is typical of southeastern Anasazi black-on-white painting styles, but the execution is more precise than normally found on Anasazi vessels. (Cat. No. 14)*

LIST OF COLOR PLATES

P L A T E 1. Jar (Olla), Anasazi, Walnut Black-on-white page ii

P L A T E 2. Bowl, Anasazi, Wingate Black-on-red vi

P L A T E 3. Bowl, Anasazi, Red Mesa Black-on-white 8

P L A T E 4. Bowl, Anasazi, St. Johns Polychrome 9

P L A T E 5. Bowl, Anasazi, St. Johns Polychrome 12

P L A T E 6. Mug, Anasazi, Mesa Verde Black-on-white 13

P L A T E 7. Bowl, Anasazi, Mesa Verde Black-on-white 16

P L A T E 8. Bowl (fragment), Anasazi, Mesa Verde Black-on-white 17

P L A T E 9. Jar, Anasazi, Kayenta Black-on-white 20

P L A T E 10. Bowl, Anasazi, Kayenta Black-on-white 21

P L A T E 11. Bowl, Anasazi, Pinedale Polychrome 24

P L A T E 12. Bowl, Anasazi, Fourmile Polychrome 25

P L A T E 13. Bowl, Anasazi, Jeddito Black-on-yellow 29

P L A T E 14. Bowl, protohistoric Hopi, Sikyatki Polychrome 32

P L A T E 15. Jar (Olla), protohistoric Hopi, Sikyatki Polychrome 33

P L A T E 16. Jar (Olla), protohistoric Hopi, Sikyatki Polychrome 37

P L A T E 17. Bowl, protohistoric Hopi, Sikyatki Polychrome 40

P L A T E 18. Bowl, protohistoric Hopi, Sikyatki Polychrome 40

P L A T E 19. Tiles, Hopi, Polacca Polychrome 41

P L A T E 20. Seed Jar, Hopi, Hano Polychrome 44

P L A T E 21. Bowl, Hopi, Hano Polychrome 45

P L A T E 22. Jar (Olla), Zuni or Acoma Pueblo, Ashiwi Polychrome 48

P L A T E 23. Jar (Olla), Acoma Polychrome............................... 52

P L A T E 24. Jar (Olla), Acoma Polychrome............................... 56

P L A T E 25. Jar (Olla), Acoma or Laguna Polychrome..................... 60

P L A T E 26. Figurine, Acoma Polychrome 65

P L A T E 27. Jar (Olla), Acoma Polychrome............................... 68

P L A T E 28. Jar (Olla), Laguna Polychrome 69

P L A T E 29. Jar (Olla), Zia Polychrome 72

P L A T E 30. Jar (Olla), Zuni Polychrome 73

P L A T E 31. Dough Bowl, Zuni Polychrome 76

P L A T E 32. Jar (Olla), Zuni Polychrome 77

P L A T E 33. Jar (Olla), Zuni Polychrome............................... 80

P L A T E 34. Terraced Bowl, Zuni Polychrome 81

P L A T E 35. Drum Jar, Zuni Polychrome................................. 84

LIST OF FIGURES

FIGURE 1. "The piki maker" .. page 2

FIGURE 2. "Pueblo Indians selling pottery in New Mexico" 3

FIGURE 3. Hopi Maidens, First Mesa 4

FIGURE 4. "The potter" ... 5

FIGURE 5. "Ancient Ruins in the Canon de Chelle, N.M." 7

FIGURE 6. Timeline ... 14

FIGURE 7. "Ruins in Mummy Cave, Canon del Muerte, Ariz." 15

FIGURE 8. "Pueblo of Acoma, N.M. Procession of San Esteban" 19

FIGURE 9. "Pueblo of Laguna, Ariz." 22

FIGURE 10. "Snake dance of the Moquis. Hualpi, Moqui Village. Arizona" 26

FIGURE 11. "A feast day at Acoma" 27

FIGURE 12. "View in Zuni" ... 28

FIGURE 13. "Pueblo of Wolpi. One of the Moki towns, Arizona" 36

FIGURE 14. Thirteenth century Anasazi tower at Hovenweep,
 southeastern Utah 38

FIGURE 15. "Zuni transportation" 43

FIGURE 16. "At the old well of Acoma" 50

FIGURE 17. Steps in forming an Anasazi or Pueblo vessel 58 & 59

FIGURE 18. Cave No. 7 in Grand Gulch, Utah 62

FIGURE 19. Battle Rock of McElmo Canyon 63

FIGURE 20. Stewart Culin, 1901 66

FIGURE 21. Frank Hamilton Cushing, circa 1897 66

FIGURE 22. Illustration from newspaper article "With Western Mummies:
 A Glimpse of Some of the Wonders of Cliff Dwellers' Relics" 67

FIGURE 23. Thomas C. Donaldson 71

FIGURE 24. Miniature seed jar, Anasazi, Kayenta Black-on-white 71

FIGURE 25. Miniature pitcher, Anasazi, Kayenta Black-on-white 71

FIGURE 26. Figurine, Acoma Polychrome 74

FIGURE 27. Ladle, Anasazi, Jeddito Black-on-yellow 78

FIGURE 28. Jar (Olla), Anasazi, Jeddito Black-on-yellow 78

FIGURE 29. Cover of A.H. Gottschall sale catalogue 82

FIGURE 30. Thomas Keam's Curio Room 100

 # PREFACE

In the initial planning of *Beauty from the Earth: Pueblo Indian Pottery from The University Museum of Archaeology and Anthropology,* it was decided that the exhibition should travel to eight venues throughout the United States and Canada, accompanied by a catalogue. By traveling the exhibition a much wider audience would be reached, and the accompanying catalogue would extend the life of the exhibition by creating a visual record of the pottery to serve as a scholarly reference for years to come.

The Museum's extensive collection of southwestern pottery, numbering well over 3500 pieces, has not been exhibited for decades. The pottery has been stored but rarely displayed or published since it was collected at the turn of the century. The importance of this collection, distinguished by its artistry, early dates of acquisition, and excellent documentation, led to the Museum's interest in sharing it with as broad an audience as possible.

The exhibition *Beauty from the Earth* was made possible through generous grants from the National Endowment for the Arts and The Pew Charitable Trusts. The preparation of the exhibition, the production of the catalogue, and the logistics of organizing a traveling exhibition are complex endeavors, to which a number of people have contributed. A special debt of gratitude goes to our colleague J. J. Brody, Professor Emeritus of Art and Art History at the University of New Mexico and curator of the exhibition, who made available his incomparable expertise throughout all phases of the exhibition's organization and production. The Museum staff found working with him a pleasure, for his gentle manner and delightful sense of humor made the tasks at hand seem almost simple. My sincere thanks go also to all the members of the Museum staff and many others who made the exhibition possible through their considerable efforts.

Robert H. Dyson, Jr.
The Charles K. Williams II Director

 # INTRODUCTION AND ACKNOWLEDGMENTS

Almost ten years ago during the icy winter of 1981, Mary Elizabeth King, then Keeper of Collections of The University Museum, showed Jean Brody and me the pottery collection that inspired this exhibition. At the time we were looking for pictures on Anasazi pottery that resembled 15th century Anasazi wall paintings, and guessed there might be some in the storerooms of The University Museum. We guessed right, but also saw so many other memorable, hidden treasures that when Pamela Hearne, Coordinator of Museum Services, years later asked me to help organize this exhibition, I agreed as though it were a civic duty. I felt this responsibility more so since the show would travel and there was a good chance that some of the collection would return to the Southwest, however briefly.

Some exhibitions are easier to organize than others. In this case the only difficulties were deciding upon a theme and then selecting from among thousands the few pots that would best illustrate it. In the end, the strengths and limitations of the collection provided the theme and the selection logic, though the final cut was agonizing and almost arbitrary. Others would have chosen differently, and there are still many potential themes to be explored, each calling for a different selection. It is a collection that will inspire quite different exhibitions in the future, for alternative interpretations are among the reasons why we have museums and museum collections.

Even when a theme is self-evident and selection simple, no exhibition is easy unless the people involved make it so. The entire staff of The University Museum of Archaeology and Anthropology are to be thanked for making this so rewarding an experience. Special thanks go to Director Robert H. Dyson, Jr. for his unfailing support; Pamela Hearne, Coordinator of Museum Services, who was a rock of stability and good sense; Rebecca Allen, Curatorial Assistant, for data, pictures, good cheer, and good questions as we handled each and every one of 3500 pots, breaking none and loosing none; Kathryn Grabowski, then Coordinator of Traveling Exhibitions, who spearheaded the initial fundraising; Lucy Fowler Williams, Assistant Coordinator of Traveling Exhibitions, for coordination and advice; Jack Murray, Exhibit Designer, and his skilled staff, especially designer Renwei Huang, for their creative solutions to difficult problems; Karen Vellucci, Managing Editor, and Catherine Ambrose, Editorial Assistant, for their combined efforts in seeing the catalogue through to its successful completion; editors Lee Horne, Jennifer Quick, and Jean Adelman; catalogue designer Dennis Roberts, whose personal ties to the Southwest helped produce a better book; Fred Schoch for his color and black-and-white photography; Alessandro Pezzati, Reference Archivist; Conservator Lynn Grant; Constant Spring Productions, Inc. for the production of the video about Acoma potter Mary Lewis Garcia; and Judith Berman, Keeper of the American Section, all of whom were unfailingly helpful. People in other departments of The University Museum were of assistance to me as well. Many thanks to Patricia Goodwin, Coordinator of Special Events and Membership, who worked together with Ann Newman and Fred Boschan to organize the pottery symposium; Pam Kosty for disseminating information about the exhibition program; Gillian Wakely and her capable staff, as well as Phoebe Eskenazi, for the planning of educational programs; and Jill Ervais and Kevin Rowley of the Museum Shop.

In New Mexico, Katherine Riley did important, frustrating research for me, and special thanks go to Professors Bill Gilbert and Jane Young of the University of New Mexico, and Mary Lewis Garcia of Acoma Pueblo and their students for making tapes of their pottery-making classes at Acoma Pueblo available for use in the exhibition. Filmmaker and friend Anita Thatcher of Black Hat Productions, New York; Joan Shigekawa; and the Program for Art on Film of the Metropolitan Museum of Art and the Getty Foundation; and Mary Lewis Garcia are also thanked for making other film footage available. And finally, to my wife Jean Brody for more reasons than can ever be listed.

J. J. Brody

MAP OF THE FOUR CORNERS AREA

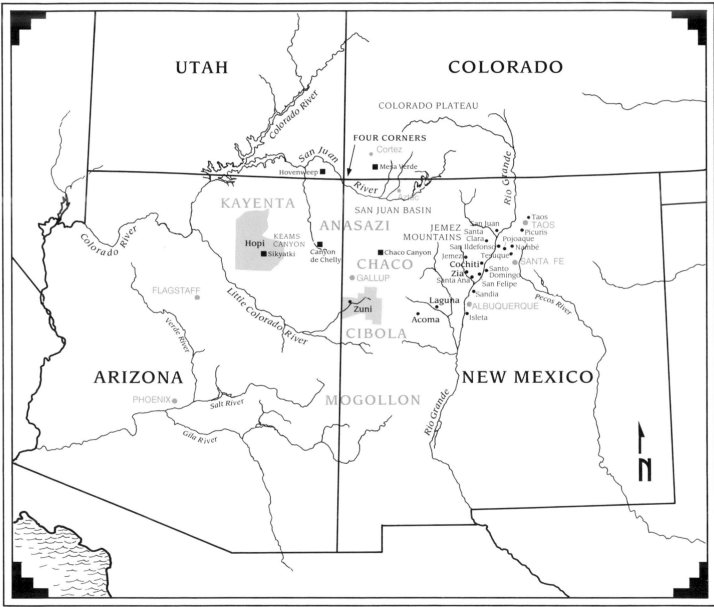

UTAH

COLORADO

COLORADO PLATEAU

Colorado River

San Juan

FOUR CORNERS
Cortez
River
Hovenweep
Mesa Verde
Aztec

KAYENTA

SAN JUAN BASIN

Rio Grande

ANASAZI

San Juan
Taos
TAOS
Picuris

JEMEZ
MOUNTAINS
Santa
Clara
Pojoaque
Nambé
San Ildefonso
Tesuque

KEAMS
CANYON
Hopi
Sikyatki
Canyon
de Chelly
Chaco Canyon
Jemez
SANTA FE

Colorado River

CHACO
Cochiti
Santo
Domingo
Zia
Santa Ana
San Felipe

GALLUP

Little Colorado River

Zuni
Sandia
Laguna
ALBUQUERQUE

FLAGSTAFF

Pecos River

CIBOLA

Isleta
Acoma

ARIZONA

NEW MEXICO

Verde River

MOGOLLON

Rio Grande

PHOENIX

Salt River

Gila River

N

DENNIS ROBERTS

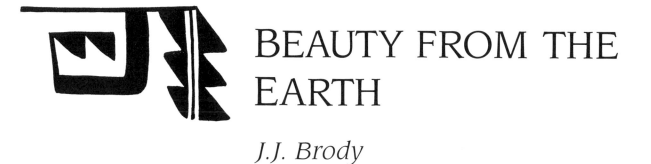

BEAUTY FROM THE EARTH

J.J. Brody

INTRODUCTION

The collection of Anasazi and Pueblo pottery at The University Museum of the University of Pennsylvania includes about 3500 pieces, most of which were acquired in the American Southwest about a century ago. Almost half the collection is of late nineteenth-century wares. Most of these are painted vessels that seem to have been made for household use at the dozen or so pueblos where pottery was still manufactured (Fig. 1). A fair number could as well have been made for sale to outsiders with no significant change in their appearance. Some are novelty pieces that were almost certainly created for the tourist trade that was just then starting to flourish (Fig. 2). The largest and most coherent groups of vessels come from the western pueblos of Laguna, Acoma, Zuni, and Hopi, but some eastern pueblos, especially Zia and Cochiti, are also well represented (Fig. 3). At the time this pottery was collected these pueblos were all small settlements—only 106 people were counted at Zia in the 1890 census, while Zuni, with 1621 men, women, and children was then, as it is now, the largest (Donaldson 1893:92–93). Those population figures reveal how remarkable in both quantity and quality Pueblo pottery was during that period, for thousands of vessels similar to these were made, collected, and taken East during the last quarter of the nineteenth century.

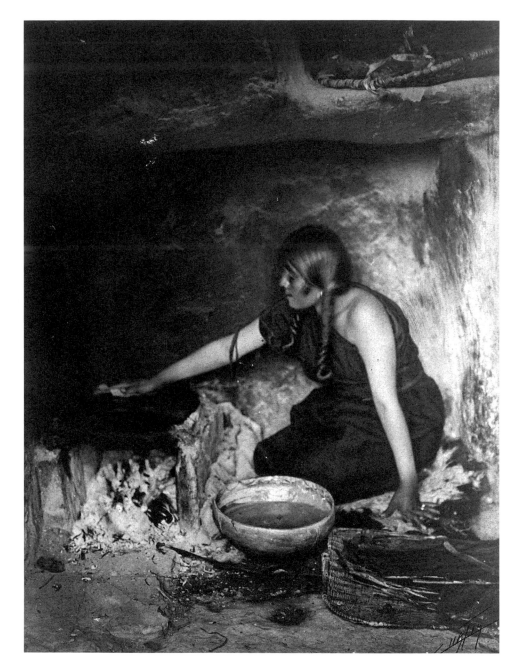

FIGURE 1. *"The piki maker."*
Photograph by Edward S. Curtis, 1906.
(neg. S8-139867)

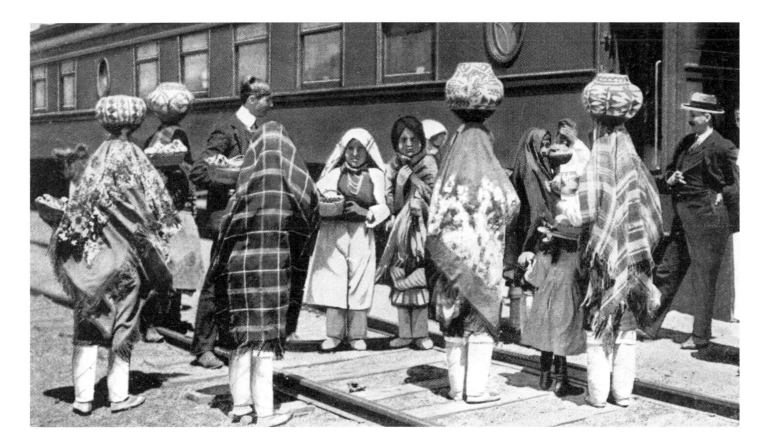

According to Thomas Donaldson (a United States census agent between 1890–1893, for more information see pp. 68–70), whose collection was acquired by The University Museum in 1901, ''. . . most of the women are pottery makers in the pueblos where pottery is made . . .'' (1893:93). His census listed 65% of all Hopi women over eighteen years of age as potters (1893:45). Pottery making was obviously an exceedingly important activity at many pueblos in those days (Fig. 4).

 Pottery that was made some five to eight hundred years earlier in the Four Corners region by the Anasazi ancestors of the Pueblo Indians comprises the other half of the Museum's collection. To an unusual degree, we know the history of the Anasazi through variations in their painted pottery art. Their wares demonstrate that the importance given to pottery by Pueblo people was no new thing, for it had been of great value to their

FIGURE 2. *"Pueblo Indians selling pottery in New Mexico." Reproduced from a postcard published by Fred Harvey, circa 1930s. (neg. 74-248)*

ancestors for many centuries. In our day it has proven to be marvelously informative about these people whose physical and social environments were (and are) quite different from what most of us are used to. Examination of the pottery's uses, forms, iconography, and styles—all of which may refer directly to the tangibles of technology as well as to intangibles such as culture history, economics, and social values—makes the art intelligible and the people who created it accessible.

As a general rule, the Euro-American ranchers, businessmen, scholars, bureaucrats, and artists who originally obtained these vessels intended for them to be taken to the eastern United States where, as archaeological or ethnographic specimens, curios, or objects of art, they would be placed in museums or in the homes of well-to-do intellectuals (see pp. 61–87 for information about the formation of the Museum's southwestern collections). As is often the case, those who selected and collected the objects and recorded information about them did so for complex reasons that may have had little or nothing to do with the concerns of the potters. The acts of selection and recording expressed values and attitudes about art, industry, and humanity that were those of the urban, industrial world of a hundred years ago rather than of the American Indian people who originally had made and used the pottery. Therefore, as well as being things made and used by members of a small-scale society, these pottery vessels are the raw materials for an intellectual history of another world. These considerations aside, the primary focus here will be upon the stylistic development of these vessels and the historical contexts in which they were made.

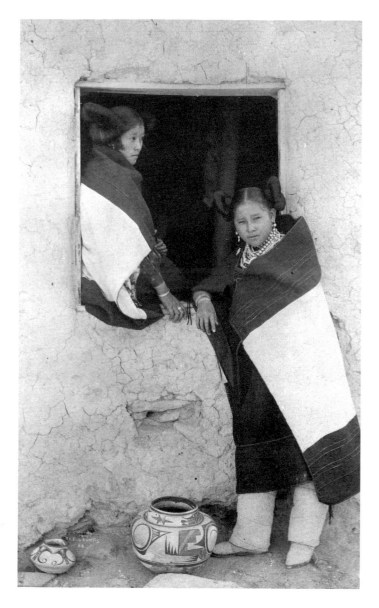

FIGURE 3. *Hopi maidens, First Mesa.*
Photograph by Edward S. Curtis, 1900.
(neg. S4-139816)

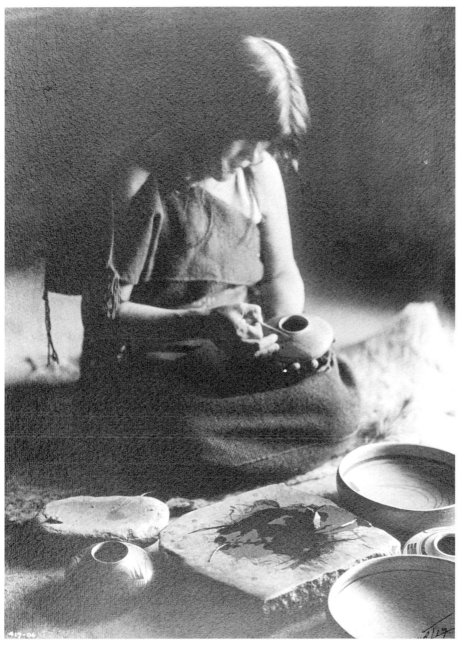

FIGURE 4. "The Potter" (Nampeyo at Hopi).
Photograph by Edward S. Curtis, 1906.
(neg. S4-139321)

PUEBLO AND ANASAZI PEOPLES

We use two different terms, "Pueblo" and "Anasazi," to distinguish between historic and prehistoric periods in the life of the same people. The Spanish, who were the first Europeans to make contact with them, called their villages and towns pueblos, and they have been known as Pueblo people ever since 1540. When the Spanish first arrived, they found more than 100,000 of the Anasazi people speaking more than a half dozen mutually unintelligible languages and living in about 100 politically autonomous towns and many smaller villages in New Mexico and Arizona (Schroeder 1979:236–254). Spanish colonization of the Southwest did not begin until 1598, and its major impact on native pottery traditions was a consequence of social disruption rather than the introduction of radical new styles or technology. In spite of dramatic changes through population losses and the attempted imposition of new economic, governmental, and religious systems on the native peoples, Pueblo pottery, a modified but uninterrupted continuation of Anasazi pottery traditions, supplied the Spanish colonists with many of their ceramic products for centuries after contact. This pottery continues to be made to the present day.

It is only since about 1930 that the word "Anasazi" has been used to refer to the prehistoric Pueblos. Our knowledge of the unwritten history of these people is considerable, largely as a result of the work of archaeologists, whose systematic investigations of the American Southwest began late in the nineteenth century. From its beginnings, archaeology in the region depended upon the plentiful and durable medium of pottery as a major source of data. It was not until after 1910, however, that effective techniques for using pottery as a sensitive temporal, social, and cultural indicator were developed, and it was not until the 1930s that all major southwestern prehistoric pottery traditions were described. Thus, the Anasazi collections of The University Museum are representative of a very early state of knowledge of the prehistoric Southwest. The very term "Anasazi" had not yet been coined, no comprehensive outline of Pueblo prehistory existed, only limited periods of that history were known, and there were as yet no bases for formulating its chronological framework.

By the late nineteenth century, however, informed people generally assumed a relationship between the modern Pueblos and the still unnamed Anasazi whose impressive ruins in the Four Corners region were just becoming more widely known (Fig. 5). But the nature of the relationship was uncertain. Place names given in the late nineteenth century by Euro-Americans to towns, counties, rivers, and the ancient

Indian ruins of their newly acquired lands call up images of the conquest of distant Mexico. Montezuma County and Cortez in Colorado, Montezuma Creek in Utah, the ruined prehistoric towns of Montezuma Castle in Arizona, and Aztec in New Mexico, even the Cumbres and Toltec Railroad in New Mexico and Colorado, testify to a fascination by the Euro-American newcomers with ancient Mexico. They tell of an assumption (if not a wish) that the majestic stone ruins of the San Juan Basin were relics of the Toltecs and Aztecs rather than of ancestors of modern-day Pueblo people.

The Pueblos and the other Native Americans of the region apparently had few doubts that the ruins and the pottery found within them were those of their ancestors. There was hardly a pueblo that did not have oral traditions connecting the historic present to these tangible evidences of an ancient, mythic past. Painted pottery was among these evidences, yet nineteenth-century Pueblo pottery was different in many ways from that found in the cliff house and great house ruins of the Four Corners area where Colorado, Utah, Arizona, and New Mexico meet. In some places resemblances between ancient and modern wares were closer than at others, but nowhere were similarities between modern Pueblo pottery and that found at the prehistoric sites of Mesa Verde or Chaco Canyon so close as to confirm an unequivocal relationship without further archaeological investigation.

Nevertheless, many, but by no means all, of the nineteenth- and early twentieth-century investigators assumed that technical qualities made identity of Anasazi and Pueblo pottery virtually certain despite evident differences in decoration and form. Tools, clay preparation, paints and slips, construction methods, even firing

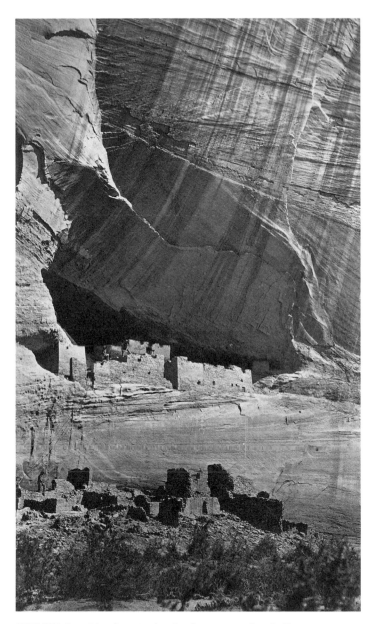

FIGURE 5. *"Ancient Ruins in the Canon de Chelle, N.M." Photograph by Timothy H. O'Sullivan, 1873. (neg. S8-139868)*

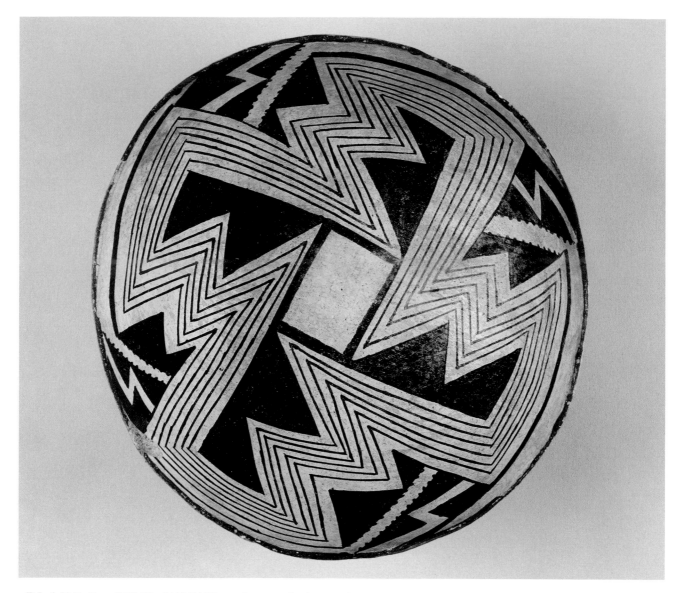

P L A T E 3. BOWL, ANASAZI, *Red Mesa Black-on-white, circa A.D. 870–950. Collected by Stewart Culin on the Wanamaker Expedition of 1901. H. 8.0 D. 21.0 cm (29-77-422). There are many local variations of this eastern Anasazi type of pottery found near Acoma and Zuni pueblos. The nervous energy and illusions of space and motion on this example from northeastern Arizona are notable. (Cat. No. 3)*

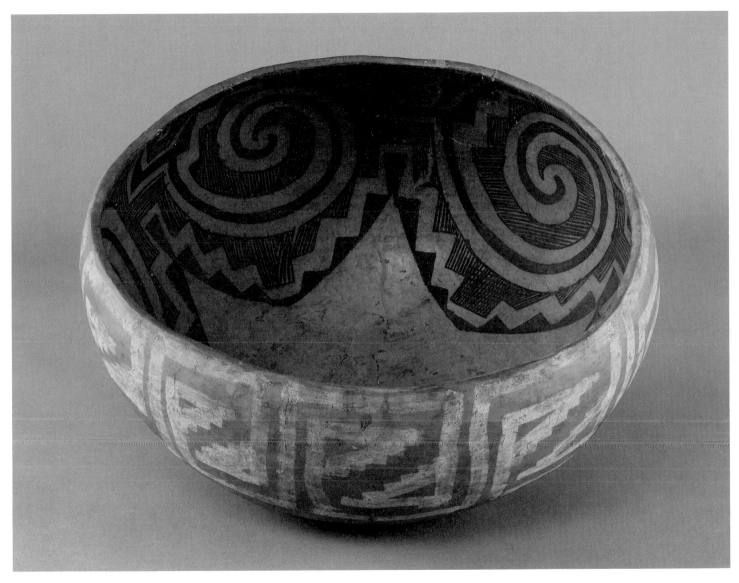

P L A T E 4. BOWL, ANASAZI, *St. Johns Polychrome, circa A.D. 1175–1300. Collected by Stewart Culin on the Wanamaker Expedition of 1901. H. 17.0 D. 31.0 cm (29-77-230). Painted stepped terraces and interlocking scrolls based on prehistoric motifs were elaborated upon during the nineteenth century ceramic revival. Compare this bowl's exterior design, typical of early polychromes, to that of a nineteenth century revival bowl (Cat. No. 22).*

procedures (despite novel fuels and other innovations) were all fundamentally identical, past and present, and obviously aboriginal rather than European in origin. Furthermore, confusion about the antiquity of specimens was a persistent problem. Anasazi vessels were sometimes obtained at modern pueblos and so thought to be modern. Even some that were collected at Anasazi ruins were assumed to have no great antiquity (Stevenson 1883:419).

A possible reason for the confusion was the fact that as the nineteenth century progressed, a self-conscious revival of very ancient designs and design methods had begun to take hold at many pueblos, as though to reaffirm Pueblo knowledge of their own past that the non-Indian world may have doubted. Some revivals had begun well before any collectors made their appearance, but it was not until after the railroad, tourism, and other intrusions that revivalism made a strong impact upon the appearance of Pueblo pottery. Revivals continued, and by the middle of the twentieth century, pottery made at many pueblos looked more like that of the distant Anasazi past than did wares made a century earlier at the same places.

Renewal of past traditions has become a major theme in the history of modern Pueblo Indian pottery. Less obvious are the persistent elements of continuity with the same past that subtly permeate many nineteenth-century wares. At the turn of the twentieth century, large segments of the continuum were missing, and the evidence of continuity was not as clear as it is today. The nature of this and other collections formed at that time, rich in the late nineteenth-century art of the western pueblos and in the pre-fourteenth-century art of the northern and western Anasazi, colored perceptions of past and present. With the exception of late prehistoric pottery recovered from sites near the Hopi pueblos, there were few very strong visual similarities between the painted pottery of modern Pueblos and the ancient wares of the Anasazi. Several hundred years of tradition were all but unknown.

Not only non-Indians lacked essential bits of information; most Pueblo potters also were missing important segments of their own past. The black-and-white pottery of the Anasazi heartland had been lost to most human knowledge for hundreds of years and was known to Pueblo potters, if at all, primarily from sherds and the occasional vessel exposed at a ruin by flood or other natural accident. The reintroduction of those and other ancient wares through the agency of pot-hunters, archaeologists, and collectors impacted upon the perceptions by the Pueblo people of their own past, just as it did upon those others who were interested for their own varied reasons in the art and the past of the Pueblos.

THE HISTORICAL BACKGROUND

"Anasazi" is a convenient term of reference for any of the many sedentary people who farmed for a living in the southern parts of the Colorado Plateau and along the drainages of the northern Rio Grande between about the fifth and seventeenth centuries of the Christian era. The term is sometimes said to mean "the ancient ones," but it is actually an English-language corruption of a Navajo Indian phrase that may best translate as "enemies of our ancestors" (Sando 1982:8,9).

The center of the original Anasazi homeland lies along the San Juan River and other tributaries of the great Colorado River in an area called today The Four Corners. Most Anasazi settlements are at elevations of 5500 to 7000 feet in a landscape of spectacular beauty characterized by cold winters, hot summers, aridity, periodic droughts, brief and potentially destructive late summer cloudbursts, great ecological variety, and a complex mosaic of natural resources. People had lived in that region for more than ten thousand years before there were any Anasazi, gleaning a livelihood by hunting and by harvesting wild plants. At least some of the Anasazi had been local hunter-gatherers who adopted a sedentary life based upon the cultivation of maize, beans, and squash, the triad of now-sacred domesticated plants of the Pueblo people which had all originated in Mesoamerica (Cordell 1984). Their pottery traditions also derived from the northern frontier of Mesoamerica. Other Anasazi migrated into the region at different times from various places.

Other sedentary, farming, pottery-making people of the Southwest included the mountain- and desert-dwellers we call the Mogollon, who became farmers earlier than the Anasazi and exerted a strong influence upon them. Ultimately, many people of the Mogollon and other societies who interacted with the Anasazi were absorbed by them, contributing mightily to the rich diversity of later Anasazi and historic era Pueblo cultures. Archaeological evidence, analogy with modern Pueblo practices, and early Spanish chronicles all reinforce the inference that each Anasazi town or village was a more-or-less egalitarian, independent society governed by elders, consensus, rules of kinship, and socially integrative religious organizations. Ritual systems often focused upon matters relating to harmony, social continuity, health, fertility, and the need for water—all major issues for the survival and well-being of their communities. Anasazi technology was appropriate to a subsistence economy in a difficult environment, but they also traded luxury goods such as turquoise and woven textiles over great distances for

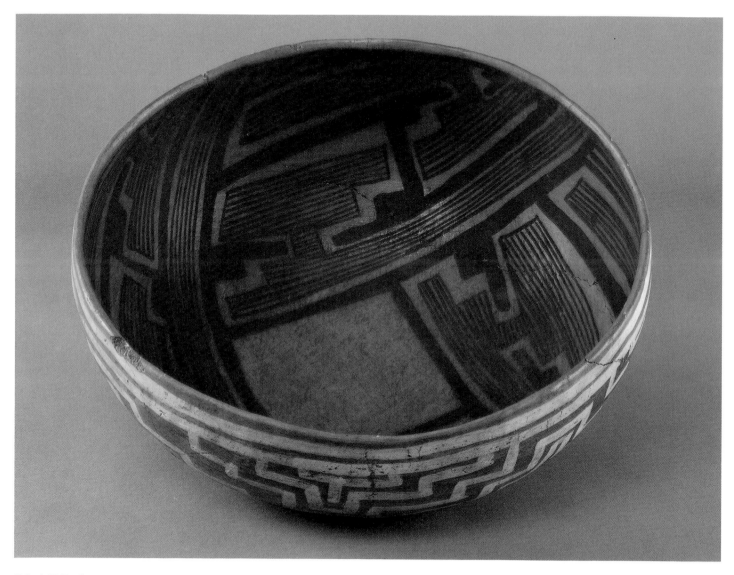

PLATE 5. BOWL, ANASAZI, *St. Johns Polychrome, circa A.D. 1175–1300. Collected by Stewart Culin on the Wanamaker Expedition of 1901. H. 15.0 D. 31.5 cm (29-78-783). Until A.D. 1000, most pottery made by Mogollon peoples of the southern Southwest was unpainted redware. From then until 1300, their creative painted wares included Anasazi-inspired black-on-white, black-on-red, glaze paint, and polychrome vessels. This Mogollon/Anasazi type, named for a town in east-central Arizona, was widely traded and influenced later Anasazi styles. (Cat. No. 23)*

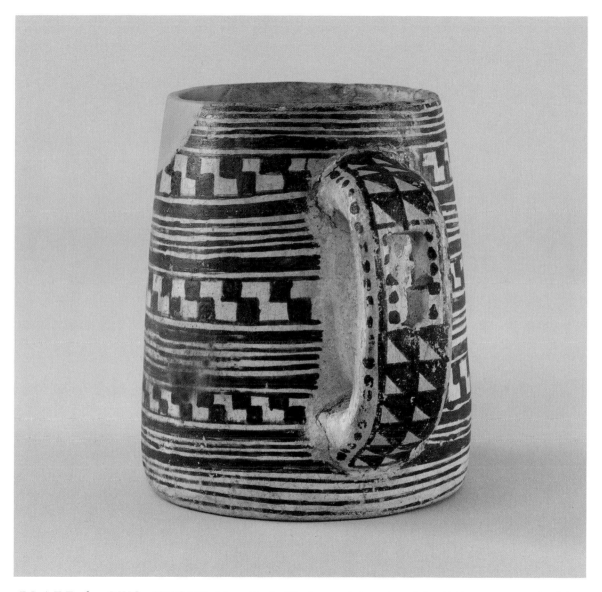

P L A T E 6. MUG, ANASAZI, *Mesa Verde Black-on-white, circa A.D. 1200–1300. Acquired by Robert K. McNeely from the Wetherill brothers in 1893 and donated to the Museum in 1895. H. 12.7 D 13.0 cm (13002). It is one example of the broad range and inventive variety of thirteenth century mugs from the region of Mesa Verde, Colorado. (Cat. No. 24)*

ANASAZI / PUEBLO CULTURE SEQUENCE
(ALTERNATE SCHEMES)

	PECOS CLASSIFICATION	ROBERTS CLASSIFICATION	RIO GRANDE SEQUENCE (After Wendorf and Reed)
AD 2000			
1900			
1800	Pueblo V	Historic Pueblo	Historic
1700			
1600	///		
1500			/////////////////////////////////////
1400	Pueblo IV	Regressive Pueblo	Classic
1300	///		/////////
1200	Pueblo III	Great Pueblo	Coalition
1100	///		/////////////////////////////////
1000	Pueblo II		
900	////////////////////////////////	Developmental Pueblo	Developmental
800	Pueblo I		
700	////////////////////////////////	////////////////////////////////	
600	Basketmaker III	Modified Basketmaker	///////////////////////////////
500			
400	///		
300			
200	Basketmaker II	Basketmaker	Pre-Ceramic
100			
AD BC	///		↓
100	Basketmaker I (Hypothetical)		
200		?	?
BC 300			
	?		

FIGURE 6. Timeline (adapted from Brody 1990).

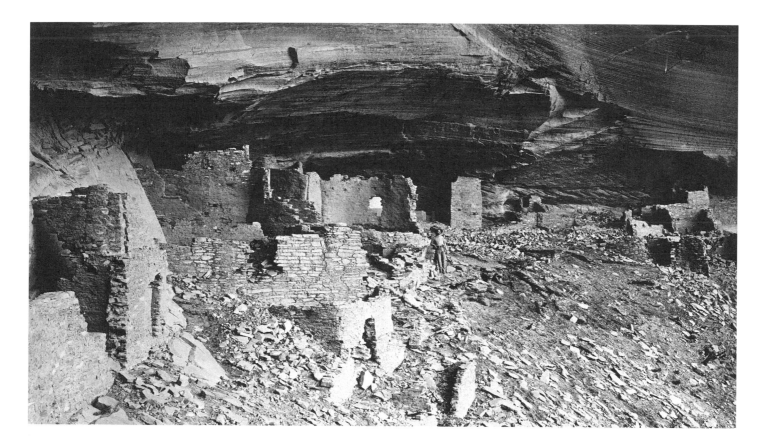

seashells, macaws, and ritual knowledge. Painted pottery was made in many places and was widely traded within a radius of several hundred miles.

Distinctive Anasazi pottery traditions began to develop in the Four Corners region during the Basketmaker III period, from about A.D. 500 to 700 (Fig. 6) (Dittert and Plog 1980). In the Developmental Pueblo era (Pueblo I and Pueblo II), from about A.D. 700 to 1100, great expansion of Anasazi population and territory took place, along with an increasing elegance and diversity of painted pottery design styles. The Pueblo III Great Pueblo or Classic Pueblo period (from about A.D. 1000 to 1150 in the Chaco Canyon region and A.D. 1100 to 1300 elsewhere) marked the climax of Anasazi life in the Four Corners. Pueblo III is best known for its architectural monuments such as the great stone houses of Chaco Canyon and the cliff houses of Mesa Verde and the Kayenta districts (Fig. 7)

FIGURE 7. *"Ruins in Mummy Cave, Canon del Muerte, Ariz." Photograph by John K. Hillers, circa 1872-79. (neg. S4-139877)*

P L A T E 7. BOWL, ANASAZI, *Mesa Verde Black-on-white, circa A.D. 1200–1300. Purchased in 1896 with funds provided by Mrs. Phoebe A. Hearst. H. 9.0 D. 19.0 cm (22976). Mesa Verde type bowls are often painted with repeat-patterns of angular motifs in a band on the upper interior wall. The overall design, boldness, and swirling curves common to this type may result from contact between Mesa Verde and southern Anasazi-Mogollon peoples. (Cat No. 27)*

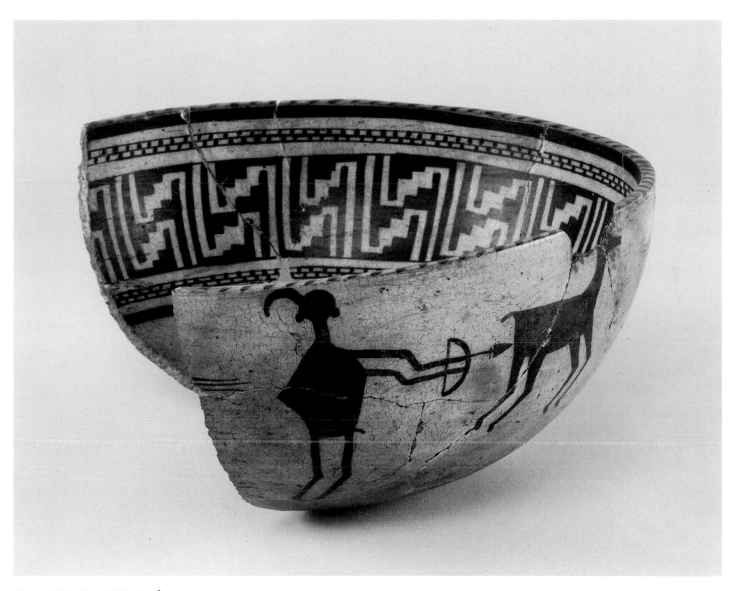

P L A T E 8. BOWL (fragment), ANASAZI, *Mesa Verde Black-on-white, circa A.D. 1200–1300. Purchased in 1896 with funds provided by Mrs. Phoebe A. Hearst. H. 15.0 D. 28.2 cm (22982). This bowl may have been whole when it was described for the World's Columbian Exposition of 1893: "On one case a Cliff Dweller is seen hunting deer with bow and arrows." Humpbacked deities are associated with hunting and fertility at some modern pueblos. (Cat. No. 28)*

(Ferguson and Rohn 1987). Community size increased significantly in this time, and economic, religious, and social cooperative networks developed in several areas. Regional pottery styles are quite distinctive, and the high general level of artistic quality suggests some degree of craft specialization.

Pueblo IV was once called the Regressive Pueblo period but is more commonly referred to today as the Coalition era. It began about A.D. 1300, following upon the widespread and exceedingly complex migrations and displacements of peoples throughout the Southwest that began in the thirteenth century; it ended with seventeenth-century Spanish political domination of the region. It was a time of radical change, as the Anasazi abandoned the Four Corners to move to the southern and eastern margins of their former homelands. They were well established in these new places when the Spanish first came, and many modern pueblos are still located at or very near to their ancestral Pueblo IV homes. In this era Mogollon and other non-Anasazi people were incorporated into the new Anasazi communities in novel social, political, and economic configurations. New religious ideas (or at least new rituals, including those of the Kachina Societies) seem to have been introduced then, and pottery styles were transformed by the invention or introduction of many innovative iconographic, aesthetic, and craft elements.

Spanish exploration of the Southwest began late in the 1530s. The 1540–1541 expedition led by Francisco Vasquez de Coronado in search of the fabled "seven cities of Cibola" was the first major *entrada* (expedition) (Simmons 1979a:178–193). In their quest for gold, Coronado's army reached the Anasazi from the southwest by way of the six Zuni-speaking towns, then moved northward to the Hopi-speaking towns and the Grand Canyon, and eastward, through Keresan-speaking Acoma, to the Rio Grande where they found other Keresan-speaking Anasazi people as well as those speaking Tiwa, Tewa, Tano, Towa, Piro, and Tompiro languages. They went as far east as Kansas, where they turned homeward in disappointment, leaving behind two of the six Franciscan friars who had come with them and a number of Mexican auxiliaries. They had fought many skirmishes with the Anasazi and had waged major battles at Zuni and at several Tiwa-speaking pueblos on the Rio Grande. They found neither gold nor great wealth, the two Franciscans were soon martyred, and many of the Mexican auxiliaries were absorbed into Anasazi communities. Some were still alive in the 1580s when the next *entradas* occurred.

The several small expeditions that came between 1581 and 1591 made their initial contacts with the Rio Grande pueblos rather than the western ones. Spanish coloni-

zation, which started in 1598, also took place in the Rio Grande drainage among the eastern pueblos. Colonization began with a very strong missionary purpose directed by the Franciscans. By the 1620s, when a number of Spanish communities were well established along the Rio Grande, large mission churches were being built at many pueblos, including the western ones of Acoma, Zuni, and Hopi (Fig. 8). A fair number of these missions were abandoned within a few years. There were revolts, priests were periodically martyred, and tensions increased owing to severe religious, economic, and political pressures applied to the Pueblos by the Spanish, especially in the east. Epidemic diseases that decimated Pueblo populations and raids by nomadic Indians who were made mobile and dangerous by their acquisition of horses added to the stresses leading up to the successful Pueblo Revolt of 1680 which expelled all Hispanics from Pueblo territories (Sando 1979).

The Spanish regained control of the eastern pueblos by 1692, but periodic revolts continued into the first decade of the eighteenth century. From then on, Spanish political and ecclesiastical control was stable but comparatively relaxed. New Mexico (which at that time included the present state of Arizona) was among the most distant, isolated, and poorest of all Spanish provinces. It was largely left to its own devices as a frontier territory valuable primarily as a buffer between Mexico and French and British North America, and later, the United States. It continued in much the same role after Mexican independence in 1821, with the economic life of Pueblo people little different from that of their Hispanic village neighbors, and all generally neglected by both church and state. By the time of the American occupation in 1846, the Pueblo population had been

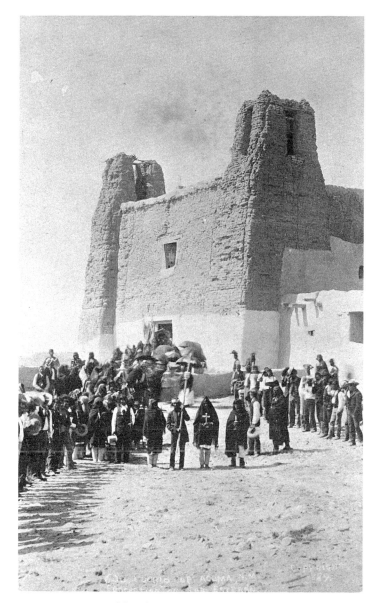

FIGURE 8. *"Pueblo of Acoma, N.M. Procession of San Esteban." Photograph by Charles F. Lummis, 1889.* *(neg. S4-139875)*

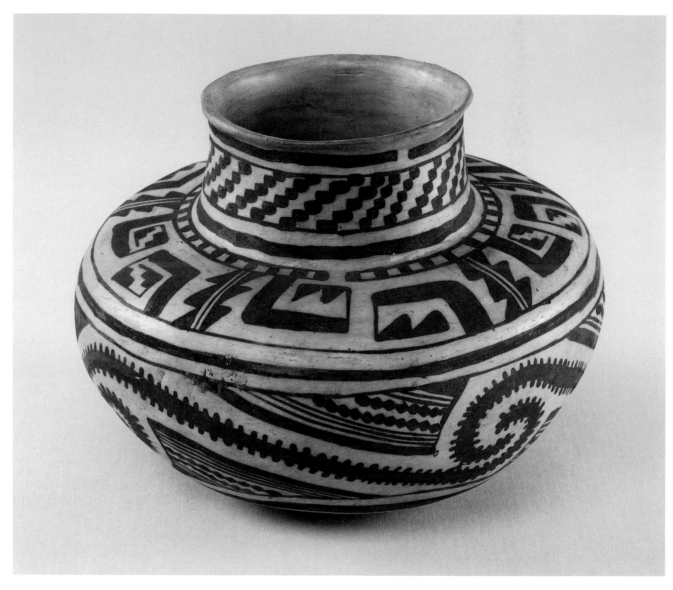

PLATE 9. JAR, ANASAZI, *Kayenta Black-on-white, circa A.D. 1250–1300. Collected by Stewart Culin on the Wanamaker Expedition of 1901. H. 14.0 D. 17.0 cm (29-77-649). This jar's shape and painting style are closely related to prehistoric Jeddito Black-on-yellow wares from the region of the Hopi mesas. Note the line-break in the framing bands which becomes a constant feature of Hopi pottery. (Cat. No. 38)*

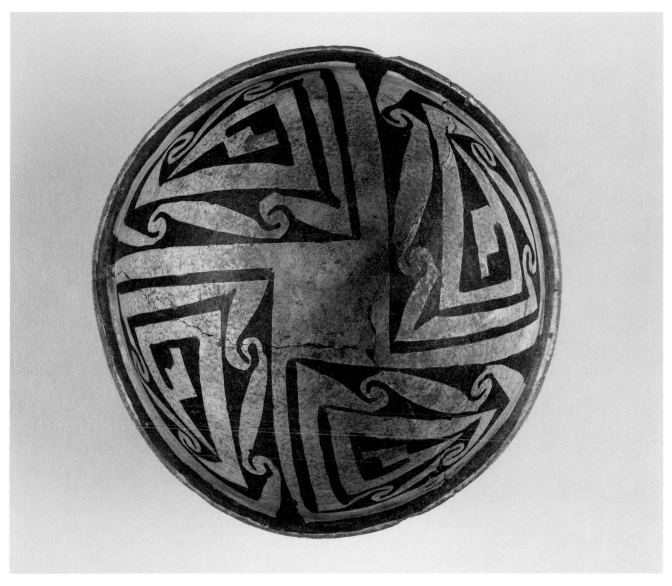

P L A T E 10. BOWL, ANASAZI, *Kayenta Black-on-white, circa A.D. 1250–1300. Collected by Stewart Culin on the Wanamaker Expedition of 1901. H. 7.5 D. 17.0 cm (29-78-954). This late black-on-white ware comes from the northern part of Black Mesa. Kayenta Anasazi peoples migrated to the Hopi mesas on the southern edge of Black Mesa. (Cat. No. 40)*

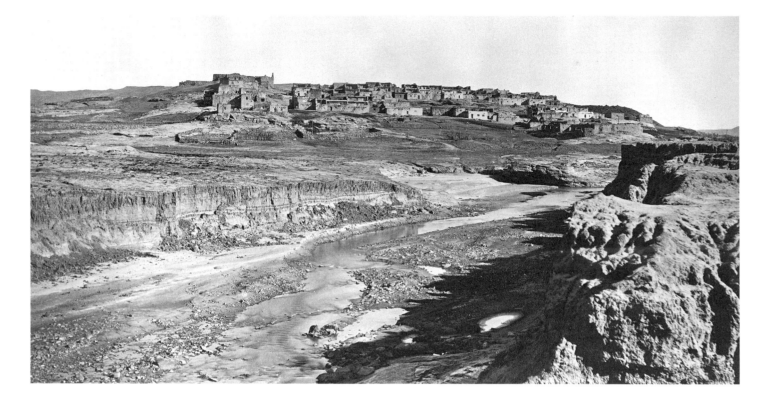

FIGURE 9. *"Pueblo of Laguna, Ariz. (sic)" Photograph by John K. Hillers, circa 1872-79. (neg. S8-139833)*

reduced to less than 10,000 people living in about twenty communities (Simmons 1979b:206–208).

The period of Revolt and Reconquest was a time of turmoil. Fear of retribution caused many eastern Pueblos and some in the west to move to defensive sites or to take refuge with the western Pueblos or in parts of the ancient Anasazi homeland that was now the home of the Navajo people. There was disruption and dissension. Some groups moved south with the Spanish; others who aided the Spanish reconquest or welcomed their return were considered traitors. Keresan-speaking Zia Pueblo, having suffered a devastating defeat by the Spanish, was shunned by its northern Keresan neighbors for later helping the Spanish. When the Hopi town of Awatovi on Antelope Mesa allowed Franciscans to return in 1700, it was destroyed by the Hopi from other pueblos (Hoebel 1979; Brew 1979). The western pueblos remained essentially independent for many years and accepted refugee groups from among the Rio Grande pueblos. Some Tiwas and

Keresans stayed at Hopi pueblos for several generations. Descendants of a southern Tewa (Tano) group founded the pueblo of Hano on Hopi First Mesa in 1696, and still live there today (Stanislawski 1979). Keresan refugees from several Rio Grande pueblos took shelter at Acoma for a few years and then formed a new community nearby that in 1697 became the Pueblo of Laguna (Fig. 9) (Ellis 1979).

During the eighteenth and early nineteenth century the eastern Pueblos interacted far more regularly with the Spanish villagers and Spanish and Mexican authorities than did those of the west. They joined with them in defense against Ute, Navajo, Apache, and Plains Indians, in warfare against the French, and, in 1847, in an abortive revolt against the American occupation. The eastern Pueblos also participated in many other of the Spanish and Mexican economic, social, ritual, and legal activities. Many pueblo mission churches remained open and in use, with or without the presence of clergy, as the modern Pueblo religions evolved.

The western Pueblos also fought occasionally with Ute, Apache, and Navajo raiders, but usually without help from the weak Spanish or Mexican militia stationed in Santa Fe. They welcomed the American occupation as a stabilizing force in the area. There were other stresses in the west. Famines in the eighteenth and early and middle nineteenth century forced many Hopis to take refuge at Zuni Pueblo, sometimes for years at a time, reinforcing strong ties between the two places that balanced a long history of occasionally acrimonious relationships. After the destruction of Awatovi, no Hispanic mission church was ever allowed at any Hopi village. The Franciscan mission at Zuni was reopened sporadically, and the mission churches at Acoma and Laguna were regularly active during a good part of the eighteenth and almost all of the nineteenth century. Disputes over land and ritual matters disrupted relationships between Acoma and Laguna during the middle years of the nineteenth century (Garcia-Mason 1979).

After the American occupation, change came slowly especially to the western pueblos where a generation passed before there were significant long-term Euro-American influences. Wagon trains passed near Laguna, Acoma, and Zuni on their way to California in the 1850s and 1860s, and there were brief contacts at those places and at Hopi villages with small parties of the military, surveyors, itinerant traders, missionaries of various sects, Indian agents, and ranchers. In the 1860s Fort Wingate was built not far from Zuni Pueblo. In that decade and the next, missions and mission schools were established by Mormons, Mennonites, and Baptists at Hopi villages, and by Mormons and Presbyterians at Zuni Pueblo. A trading post and permanent residence was built by Thomas Keam at

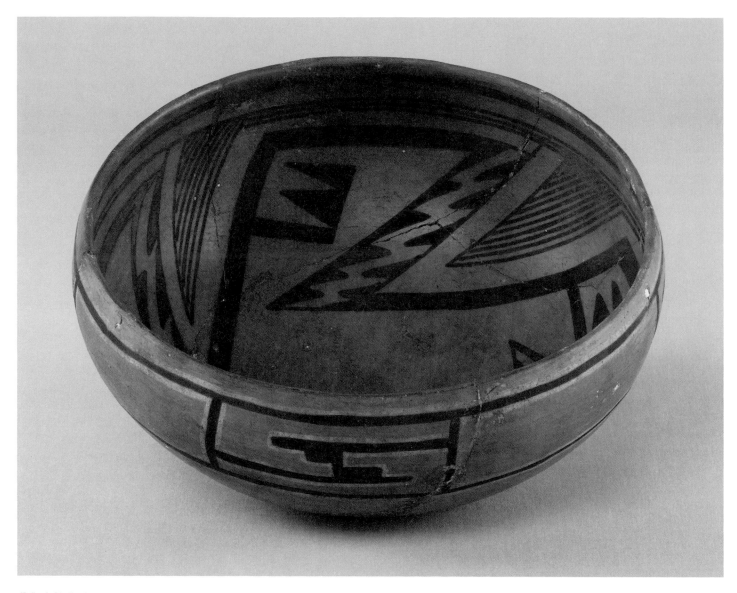

PLATE 11. BOWL, ANASAZI, *Pinedale Polychrome, circa A.D. 1275–1325. Collected by Stewart Culin on the Wanamaker Expedition of 1901. H. 11.0 D. 24.5 cm (29-78-715). The precise paintings from the Anasazi-Mogollon border region had great appeal to nineteenth century potters at Zuni, Acoma, and Laguna pueblos. Their influence is most visible today at Acoma. (Cat. No. 44)*

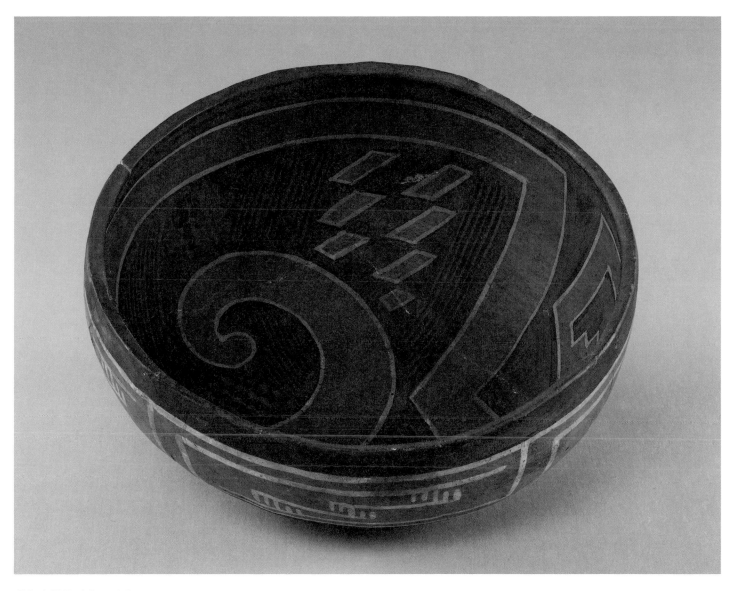

P L A T E 12. BOWL, ANASAZI, *Fourmile Polychrome, circa A.D. 1300–1400. Collected by Stewart Culin on the Wanamaker Expedition of 1901. H. 9.5 D. 21.0 cm (29-77-214). Colors and textures differ, but origins of some aspects of Sikyatki-style pottery may be found in the Mogollon-Anasazi border area of eastern Arizona. The shiny, glaze-like paint resembles glazes used by Zuni, Acoma, and Rio Grande Anasazi from A.D. 1300 to 1700. (Cat. No. 45)*

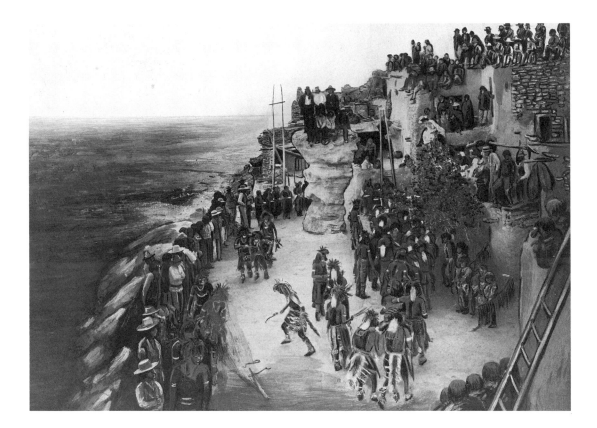

FIGURE 10. *"Snake dance of the Moquis. Hualpi, Moqui Village. Arizona (Hopi)." Photograph by Ben Wittick, circa 1890. (neg. S8-139861)*

Keams Canyon, not far from Hopi lands, in 1875. A boarding school for Indian children was established there in 1887, setting the stage for agonizing schisms among the Hopi a few years later. Several Euro-American families settled at Laguna Pueblo in the 1870s, intermarried, and became active in the political, economic, and religious life of that town.

Especially after the intercontinental railroad came through in the early 1880s, the pace of change accelerated at all of the pueblos. In 1879 the first large-scale ethnographic expedition came to the Southwest, sent by the Smithsonian Institution to collect Pueblo materials, especially pottery, for the United States National Museum (Stevenson 1883). Many other ethnographic, archaeological, and collecting expeditions sponsored by major research institutions soon followed. When the railroad simplified access to the once remote pueblos, the professional researchers were joined by a host of curious lay people who came to observe a ''primitive'' alien people and to experience exotic native rituals.

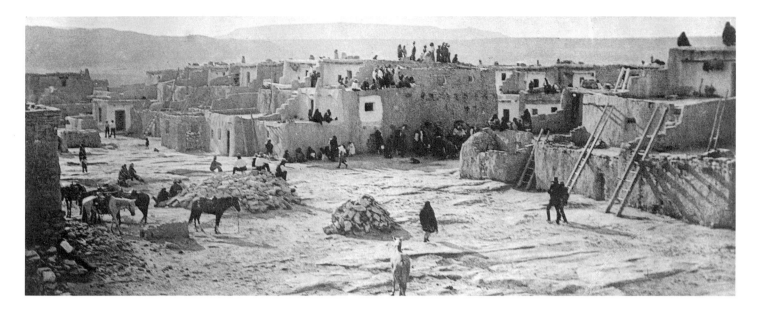

The Hopi Snake Dance, Hopi and Zuni masked kachina dances, and the unmasked line dances and animal dances that the Rio Grande pueblos permitted outsiders to view were major attractions (Fig. 10). Pottery and other native crafts became important mementos of such experiences.

FIGURE 11. *"A feast day at Acoma." Photograph by Edward S. Curtis, 1904. Reproduced from* The North American Indian, *Vol. 16, Pl. 565. (neg. 45547)*

The eastern Pueblos, after centuries of proximity to Spanish authorities committed to suppressing their religious and social institutions, were far more concerned about their privacy than were the western ones. They had well developed techniques for coping with unwanted visitors and were generally able, when they wished, to keep a distance between themselves and over-curious strangers. To a large degree they marketed their pottery and other collectibles through the shopkeepers of Santa Fe, itinerant traders, or by direct sale at railroad stations. Zuni and Hopi Pueblos were not only more open to anthropologists and other prying individuals, but were also viewed as more aboriginal and less tainted by close contact with Euro-Americans than the other pueblos. Therefore, they became the prime destinations of both lay and professional investigators and collectors who, if not deliberately, then solely by their presence became the agents of change. Acoma and Laguna ranked between the eastern and the western pueblos in their attitudes toward outsiders, in the strategies used in dealing with them, and in the outsiders' evaluations of their aboriginal "purity" (Fig. 11).

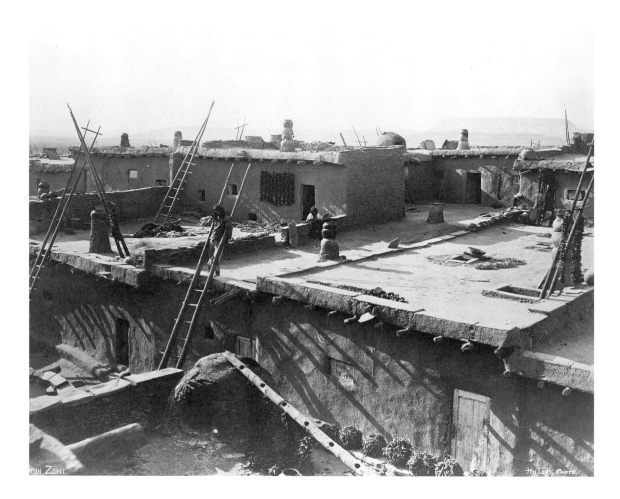

Because Zuni Pueblo was both more "pure" and more hospitable, in 1879 Frank Hamilton Cushing extended an ethnographic collecting trip and chose to remain there for almost five years (Fig. 12). Beginning at about the same time and continuing into the twentieth century, Thomas Keam and his friend Alexander Stephen (who died in 1894) found themselves hosting and training a small army of anthropologists intent upon investigating the Hopi pueblos (Wade and McChesney 1980). Keam, more than anyone else, was responsible for the excavation of Sikyatki wares and other late prehistoric and early historic pottery from Pueblo IV Hopi sites on Antelope Mesa and First Mesa. He, and Stephen even more so, were driven by their own interests in the Hopi people and Hopi

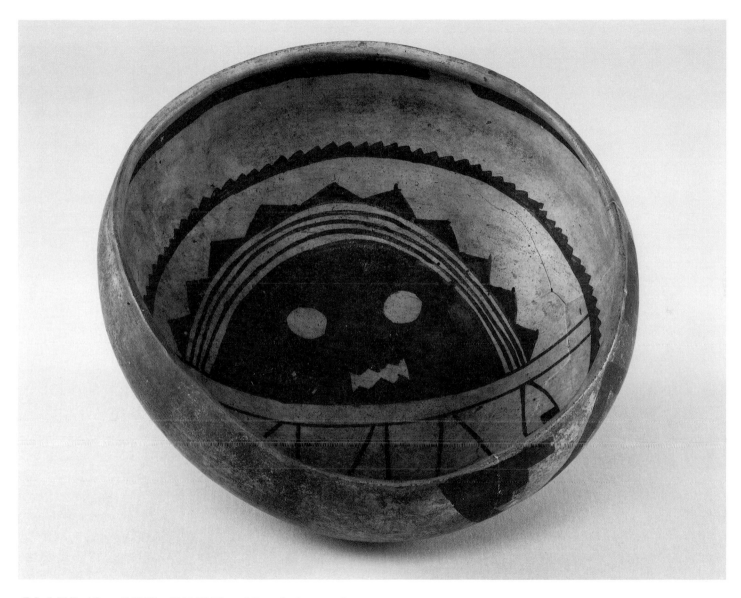

P L A T E 13. BOWL, ANASAZI, *Jeddito Black-on-yellow, circa A.D. 1400–1550. Collected by Stewart Culin from Thomas V. Keam in 1901. H. 9.5 D. 23.5 cm (39038). This Sikyatki-style bowl was recovered from the Antelope Mesa ruins of Kawaika-a. The Kachina mask with eagle feathers suspended from it is painted in the tradition of ritual wall paintings found at the same site, which was probably abandoned by A.D. 1550. (Cat. No. 48)*

culture as well as by the potential market for the Hopi pottery to be found among museums and individual collectors. By commissioning copies of ancient wares to be sold to museums, Keam seems also to have initiated the revival of ancient Hopi pottery styles that came to be associated with the Hopi-Tewa potter Nampeyo.

Soon, guided tours to the pueblos and to Anasazi ruins were commonplace. By the end of the century, a large-scale, tourist-oriented ethnic curio industry was established, with Pueblo pottery among its central products. From well before the turn of the century, Hopi, Zuni, and to a lesser degree Acoma and Laguna were considered the least "spoiled" of the pueblos, the most open to strangers, and the most difficult to reach. Their pottery was still utilitarian, distinctive, nicely crafted, and generally considered more purely aboriginal than that of the Rio Grande pueblos. For all of these reasons it was especially desirable and thus heavily represented in collections assembled at that time.

PREHISTORIC POTTERY

Anasazi painted pottery was plentiful, variable, and expressive of the values, personalities, and histories of the ancient Pueblo people. Variations in painting styles and ceramic technology identify distinctive groups within the Anasazi who might otherwise remain unrecognized and are evidence of chronological, social, religious, and other historical relationships among them.

Even taking regional variations into account, prehistoric ceramic practices were essentially alike and differ only in detail from those of modern Pueblo potters. In most places, pottery was probably made and ordinarily decorated by women who learned the craft from their kin. Mineral and carbon based paints were used, sometimes in combination. In late prehistoric times true glazes were also used as paint but never to cover an entire vessel. Painted wares were utilitarian—made to store and serve food and water—and for ritual purposes. They were also much more—regional and local styles evolved that were statements of place, values, and affiliations among groups of people.

For almost a thousand years, from Basketmaker through Pueblo III times, Anasazi potters had shown a preference for making gray- or white-ware vessels rather than the red or brown wares commonly made by their neighbors, including the Mogollon. Initially, relatively few pots were painted; most of those used narrow, black lines applied to smoothed gray paste or a thin white slip. By the seventh century, even though style

differences between them were not yet obvious, two regional black-on-white styles had begun to evolve. In the south and east, in the Cibola and Chaco Canyon districts, iron-bearing mineral paints were used. These tended to create a hard-edged line which fired with a reddish color when oxidized. Slips were generally chalky white and not highly polished. In the north and west, in the Mesa Verde and Kayenta regions, carbon based paint was preferred. This paint sank into thicker white slips that are sometimes translucent and often highly polished and crackled. The resulting line has a soft edge and a gray tone. These co-traditions, though based on technical preferences, had profound effects on evolving design styles in the two regions which are still evident on modern Pueblo wares.

Very early Anasazi black-on-gray or black-on-white pottery was rather hesitantly painted with stiff, scraggly lines in simple, overall patterns. By about A.D.600, paintings became more highly structured and were often organized within framed bands that were filled with geometric motifs in symmetrical patterns, many of which were derived from Basketmaker weaving traditions. From then on, mathematically rational designs that were integrated with vessel form, and painted slowly and carefully with complex symmetries and figure-ground inversions are the rule rather than the exception in Anasazi pottery painting. In the Developmental Pueblo era and continuing through the Classic period, carbon and mineral paint preferences had critical effects upon the evolving regional styles, each of which had many variants. In those times Anasazi pottery styles began to exert a wide influence over neighboring styles as seen in, for example, the eleventh-century transformation of the painted pottery of the Mimbres Branch of the Mogollon (Brody 1977).

In the mineral paint regions, especially in the Chaco Canyon district, angular, fine-line hachured designs that used stiff, jerky, tense lines were preferred. Solidly filled design units were sometimes combined with hachured zones to create a range of tones from black through gray to white, but the color balance generally favored white over black. Where carbon paint was preferred, linework was usually broader and smoother, designs tended to emphasize contrasting masses of dark and light, and the balance of color often favored black over white. White-slipped backgrounds were sometimes so covered by black paint as to be reduced to nothing more than thin white lines. Intermediate grays made by hachuring were not common. Deliberately ambiguous, smoothly flowing positive-negative patterns were created, especially in the Mesa Verde area. Textile designs were often seen on pottery vessels of the Kayenta district.

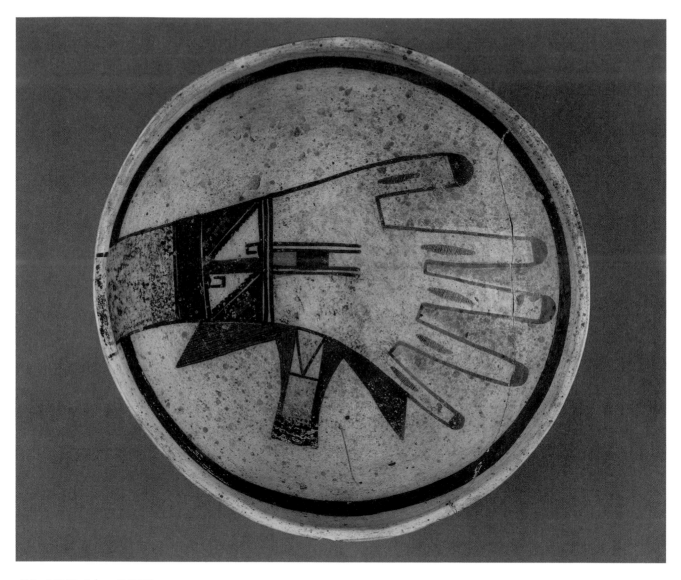

PLATE 14. BOWL, *PROTOHISTORIC HOPI*, *Sikyatki Polychrome, circa A.D. 1400–1550. Collected by Stewart Culin from Thomas V. Keam on the Wanamaker Expedition of 1901. H. 9.5 D. 26.0 cm (39051). The painting on this bowl is in the ritual mural painting tradition of Kawaika-a, the site where the bowl was found. The hand breaking through the rim-band covers a flying bluebird, and seems to belong to the body of a sky-living deity. The splattered paint suggests sky, and engraved lines add detail and strength to the composition. See Figure 10. (Cat. No. 52)*

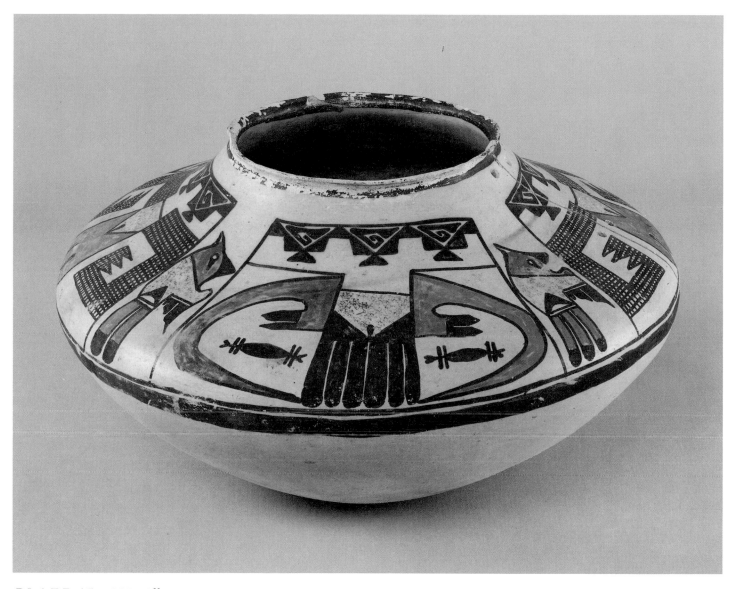

P L A T E 15. JAR (Olla), *PROTOHISTORIC HOPI, Sikyatki Polychrome, circa A.D. 1400–1625. Collected by Stewart Culin on the Wanamaker Expedition of 1901. H. 22.0 D. 37.0 cm (29-77-73). Stylized bird tails, wings, and four crested birds are painted on this vessel. The painted terraced motifs are identical to textile designs painted and embroidered on Anasazi garments, and are still found on Pueblo ceremonial clothing today. (Cat. No. 54)*

In all areas, typical pottery painting incorporated tightly drawn, angular or curved black lines to subdivide bowl interiors or jar exteriors into closed design zones whose shapes were responsive to the form of a vessel. Lines that frame design zones define the point where the neck meets the body of a jar or where the shoulder of a spherical vessel sloped downward. Framing lines were also placed on the rim of a bowl and where its wall meets the bottom plane, thereby establishing the upper wall of the vessel as a closed picture space. When overall patterns were used, designs were shaped to conform to the contours of a vessel, and the paintings expand or contract as though paint were a flexible film placed over an expanding and contracting bulbous form.

These integrative structural concerns are consistent and predictable. Precisely executed designs circulate around the center of a vessel, repeating their logical, balanced symmetries with arithmetic regularity and stately rhythm. The small-scale hachured or solid geometric elements that fill design zones have parallel logical consistencies. Scrolls, frets, ticked lines, angular sets of facing triangles, and other geometric motifs derived from older basketry and textile arts are ubiquitous. They are paired and interlocked, the spaces between sets of positive figures, especially lines of triangles, become negative motifs that move in opposite directions and lock the positive forms in place. Complexity is the product of precise execution and repetitive play with simple and predictable elements.

The population movements and realignments of the thirteenth and fourteenth century radically altered these pottery traditions. The border area between Anasazi and Mogollon regions became a major center for change, especially along the drainage of the upper Little Colorado River where polychrome and glaze painting techniques were invented along with novel pictorial systems that spread widely in the following centuries (Carlson 1970). After A.D. 1300, polychrome wares using white paint and black, brown, purple, and other glaze colors on red, orange, or yellow slips were made in many places in the Cibola district by ancestors of the Zuni and Acoma people and by many of the eastern Anasazi. The westernmost Anasazi potters in the Hopi region developed a dynamic, iconic painting style that exploited the unique qualities of coal-fired yellow clay and made unusual use of dry-brush, spatter, and engraved textures. There were pockets of carbon paint black-on-white or black-on-gray production, especially in the Jemez Mountain-Pajarito Plateau region of the northern Rio Grande where some Mesa Verde people are thought to have migrated. But even there the forms of the pottery and the character of pottery painting were radically altered. In all areas Pueblo IV painting styles

provided the foundations for protohistoric and historic era painted pottery traditions.

Bowls were now generally larger, more shallow, and painted on both visible surfaces with entirely different patterns on each side. The dominant new jar form was a wide-mouthed, low vessel with a broad sloping shoulder that was the focus for design zones that were usually subdivided into panels. Linearity was still important but hachuring was virtually abandoned, replaced by fields of color; and line quality was dramatically different—thicker, more fluid, at times almost sloppy. Most painted vessels were probably made for secular purposes, but new designs were introduced and the old geometric elements and motifs were often recombined to become feathers, birds, sun symbols, and other emblems of Pueblo sacred iconography. Often large and isolated, these motifs gave many painted vessels of this time a ritual character. The quiet, self-contained, small-scale, symmetrically balanced and geometrically complex designs of earlier days were now frequently replaced by paintings dominated by a large scale image that was sometimes asymmetrical and usually placed within a picture space framed by small-scale decorative elements.

Except for their knowledge of Hopi wares and some Little Colorado polychromes, the collectors and the Pueblo potters of the late nineteenth century were only marginally aware of Pueblo IV pottery styles. Pueblo II and III black-on-white wares recovered from the cliff houses and great houses of the Four Corners area were becoming better known and deeply admired by a wide audience; nineteenth-century Pueblo wares were also becoming familiar to the general public. The pottery produced during this fruitful and dynamic period (Pueblo IV), however, when polychromes replaced black-on-white wares, shiny glazes replaced matte paints, and an entirely novel iconographic and decorative system came into use, was as yet unknown. Relationships between Anasazi pottery of the black-on-white eras (Pueblo II and III) and nineteenth-century Pueblo polychrome wares could not be understood without reference to those Pueblo IV traditions.

POTTERY OF THE PROTOHISTORIC
AND HISTORIC ERA: 1540–1880

There is no particular reason why Pueblo IV and early historic pottery traditions should have been better understood than they were late in the nineteenth century. The historical framework was only then beginning to be outlined. One area of ignorance was

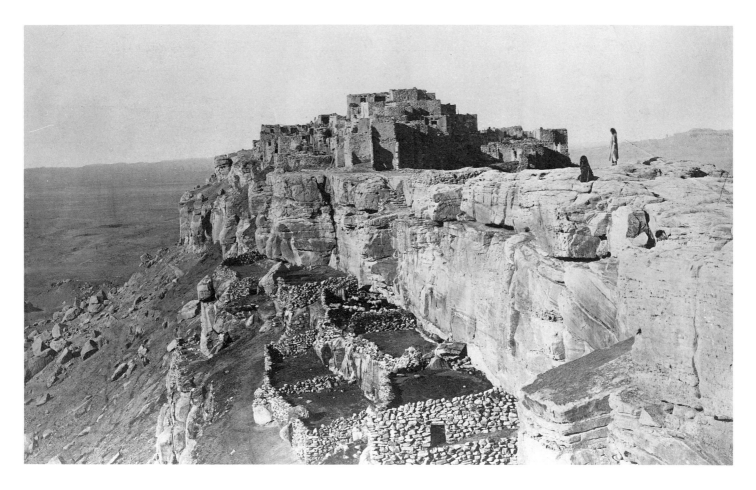

FIGURE 13. *"Pueblo of Wolpi, One of the Moki towns, Arizona (Hopi)." Photograph by John K. Hillers, circa 1872-79. (neg. S8-139828)*

no more important than any other, while few were well defined. There were negative factors also. Investigations of late prehistoric and early historic periods were inhibited by the fact that most nineteenth-century pueblos were located at or near the towns of their immediate ancestors (Fig. 13). For that reason, many of those places, even those that were long abandoned, were simply less accessible than were the ruins of Four Corners Anasazi communities. The free-wheeling excavations by archaeologists, pot-hunters, and casual adventurers that had brought earlier Anasazi pottery to light in the 1880s and 1890s was just not possible at many Pueblo IV sites, and comparatively few of them were investigated in those years.

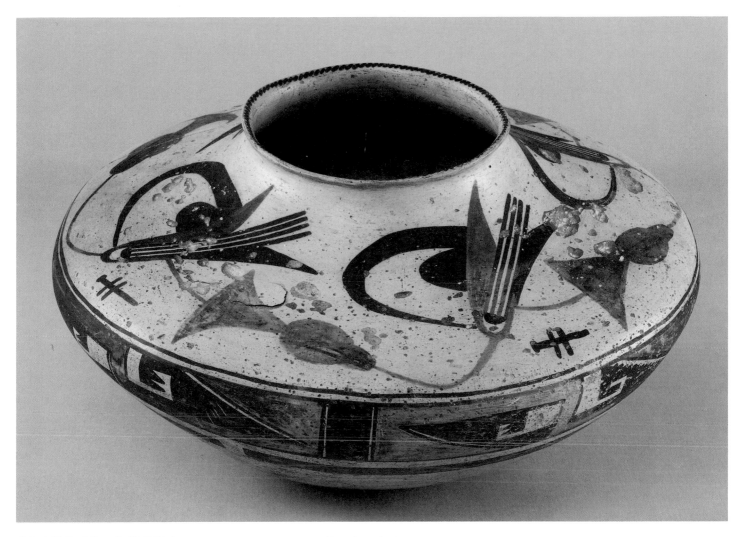

PLATE 16. JAR (Olla), *PROTOHISTORIC HOPI, Sikyatki Polychrome, circa A.D. 1400–1625. Collected by Stewart Culin on the Wanamaker Expedition of 1901. H. 22.0 D. 36.0 cm (29-77-703). Freely painted squash blossoms, stylized dragonflies, and ears of corn decorate the upper shoulder of this jar. The band below is far more rigidly organized, as are paintings on Sikyatki bowl exteriors. (Cat. No. 57)*

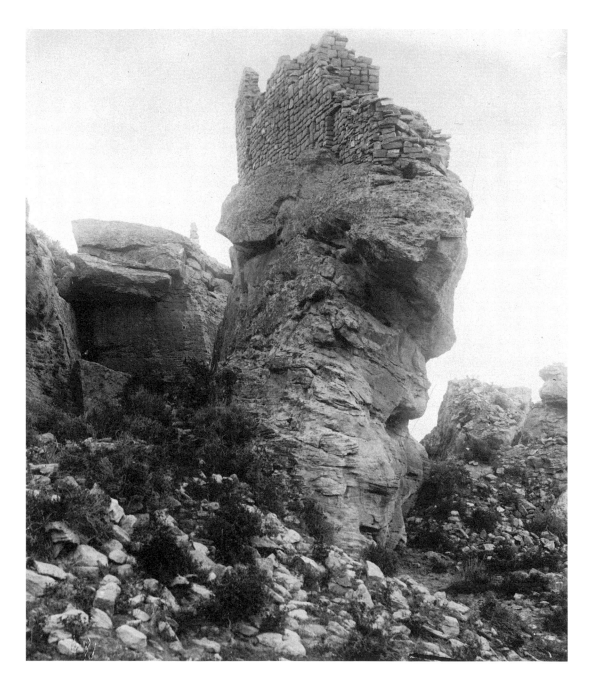

FIGURE 14. *Thirteenth century Anasazi tower at Hovenweep, southeastern Utah. Photograph by the H. Jay Smith Exploring Company, 1891. (neg. S4-139874)*

Perhaps most important was the matter of value judgments. Although many Pueblo IV ruins are of towns every bit as large and elaborate as those of earlier times, few have the aesthetic or romantic attraction of Classic period cliff houses and great houses. Most are of mud adobe that melted into shapeless mounds when they were abandoned or are relatively crude masonry structures that have not aged gracefully. Even the standing ruins and cave rooms of the Pajarito Plateau (which inspired Adolf Bandelier's novel about ancient Pueblo people, *The Delight Makers*), are only marginally photogenic when compared to the Anasazi buildings of Chaco Canyon, Mesa Verde, Hovenweep and Canyon de Chelly (Fig. 14). Similarly, the bold, spontaneous, expressive qualities of most Pueblo IV pottery had little appeal to late nineteenth-century tastes, which delighted in the precision, symmetry, and clear rationality of Classic period Anasazi black-on-white wares. Except for widely admired Pueblo IV Hopi vessels painted in the style named for the First Mesa Hopi town of Sikyatki, both the pottery and the architecture of the period that the archaeological community came to call "Regressive" was considered by many authorities to be degenerate. There was little incentive to acquire any of it.

The Pueblo IV era overlapped with the early historic period, and the sixteenth- and seventeenth-century Spanish explorers and colonists found Pueblo IV wares attractive. Their chroniclers expressed admiration for the industry and artistic skills of the women who made that pottery: "(they) have a great deal of crockery . . . all decorated and of better quality than the pottery of New Spain (Mexico) . . . so excellent and delicate that the process of manufacture is worth watching; for they equal, and even surpass, the pottery made in Portugal." (Hernan Gallegos, 1581 *in* Hammond and Rey 1966:82–86). Pueblo pottery served Hispanic needs for storage, cooking, dining, and decorative and ceremonial containers throughout the Colonial and Mexican periods. Not until the Santa Fe Trail opened in the 1820s did industrially made metal, glass, and ceramic containers begin to replace Pueblo pottery. The replacement process was not completed until after the railroad came through, more than a generation after the 1846 American conquest of the region. Until that time, Pueblo pottery was both a utilitarian and a decorative product that functioned in both the Pueblo and Euro-American worlds.

Despite their admiration for the pottery and dependence on it, there are no known Hispanic collections of early historic Pueblo pottery, and comparatively few examples from this period survive. Therefore, the nineteenth-century vessels collected by Euro-Americans from the 1870s onward, close in time to the major utilitarian ceramic traditions of the Pueblo-Hispanic Southwest, have special historic interest. Their forms,

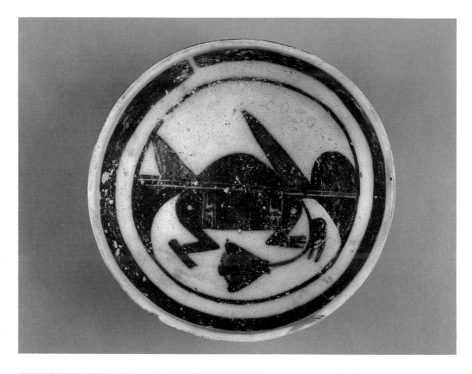

PLATE 17. BOWL, *PROTOHISTORIC HOPI, Sikyatki Polychrome, circa A.D. 1400–1625. Collected by Stewart Culin on the Wanamaker Expedition of 1901. H. 9.7 D. 24.5 cm (29-77-723). The interior of this bowl acts as a framed picture space in which a fantastic creature is shown holding a feather fan. The finely painted exterior design of stylized feathers is unusual. (Cat. No. 58)*

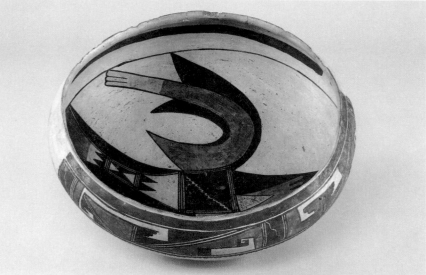

PLATE 18. BOWL, *PROTOHISTORIC HOPI, Sikyatki Polychrome, circa A.D. 1400–1625. Collected by Stewart Culin on the Wanamaker Expedition of 1901. H. 13.5 D. 32.0 cm (29-77-725). The color, texture, asymmetry, and iconography of the Hopi Sikyatki style is far different from earlier Anasazi pottery paintings. Painted interlocking scrolls of earlier traditions here become the wings of an abstract, flying bird. (Cat. No. 59)*

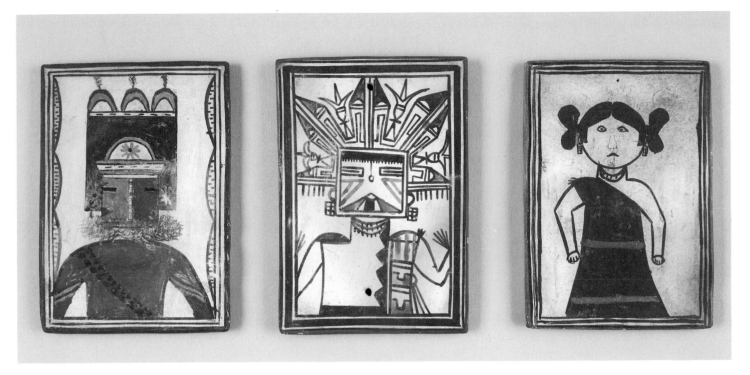

PLATE 19. TILES, *HOPI, Polacca Polychrome, circa A.D. 1885–1900. Collected by Amos H. Gottschall probably between 1897–1900 and loaned by The Academy of Natural Sciences of Philadelphia. L. 16.0 W. 11.0 cm (L-85-945,946,947). Tiles seem to have been invented as a trade item by Thomas V. Keam, who established a trading post near the Hopi villages and helped Hopi artists adjust to the new tourist market. The paintings on these three tiles, which were inspired by the complex Hopi religious pantheon, include Corn Maiden (L-85-945), Niman (Going Home) Kachina (L-85-947), and Butterfly Maiden (L-85-946). (Cat. No. 68)*

decorative styles, and imagery were modifications of late Pueblo IV and protohistoric traditions. They are expressions of relationships between the Pueblos and the Hispanic colonizers of the region whose arrival in 1598 marked the beginning of the end of the Pueblo IV era.

THE GROWTH OF REGIONAL TRADITIONS

James Stevenson, who was in charge of the 1879 expedition of the Smithsonian Institution, was fully aware that painted pottery could be distinctive from pueblo to pueblo. He considered the different styles to be "ethnic markers" though he did not use the term (1883:328–334). In earlier times, style distinctions were much less pueblo-specific and not nearly so elaborated but seem still to have functioned as regional and social identifiers. Differences in painted pottery between the northwestern and the southeastern parts of the Anasazi world are barely visible in the eighth century, but by the thirteenth century, several regional traditions are recognizable. The differences among them are visually subtle, and there is considerable overlap from area to area; it is not until Pueblo IV times that visually distinctive regional traditions are easily recognized. In that era also, variations of regional styles can for the first time be associated with clusters of pueblos whose linguistic and ethnic affiliations are documented. The particularity of nineteenth-century painting styles, generally identifiable on a pueblo-to-pueblo basis, is a fact of the historic era that seems to be not much older than the nineteenth century.

The major Pueblo IV traditions lasted, with variations, until the time of the Pueblo Revolt of 1680. In the protohistoric years, from 1540 to 1680, the dynamic, iconic, textural paintings of the Sikyatki style, in black and red or orange on polished yellow surfaces, continued at the Hopi pueblos. Bold designs in black, brown, green, and purple glaze paints on white or red slips typified wares in the Zuni-Acoma region of the Cibola district. Many variations of glaze-painted polychromes and some matte-painted polychromes were still made at numerous Rio Grande pueblos south of Santa Fe. Spontaneously applied black carbon paint on white, dull gray, or creamy surfaces still characterized the pottery of the many Jemez Mountain-Pajarito Plateau pueblos northwest of Santa Fe.

A few new shapes were added to the inventory of painted vessels, and some old ones were modified. Bowls tended to be wider and deeper than in the past, and their rim

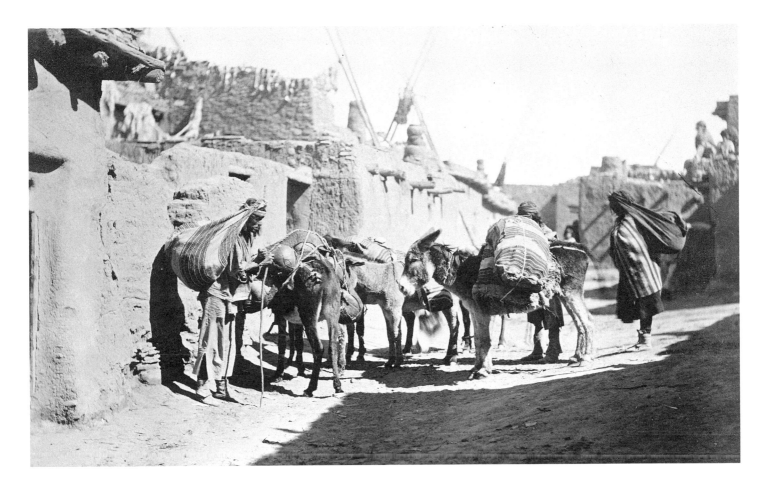

profiles were elaborated. A soup-bowl with a wide lip came into use. Tall, wide-mouthed, large jars with a low center of gravity, a bulging waist, and an indented base, first made at the eastern pueblos, came to influence vessel shapes throughout the Pueblo world. These were formed in basketry or pottery base molds that were used by potters as a kind of turntable to facilitate their work. The bulge occurs where the confining mold ended, at the point where the still plastic clay might begin to slump. That technological feature came to be decoratively elaborated upon at different pueblos from this time forward. Among exotic shapes were a variety of canteens, including some that held up to five gallons and weighed close to one hundred pounds when filled (Fig. 15). Small vessels

FIGURE 15. *"Zuni transportation." Photograph by John K. Hillers, circa 1872-79. (neg. S4-139876)*

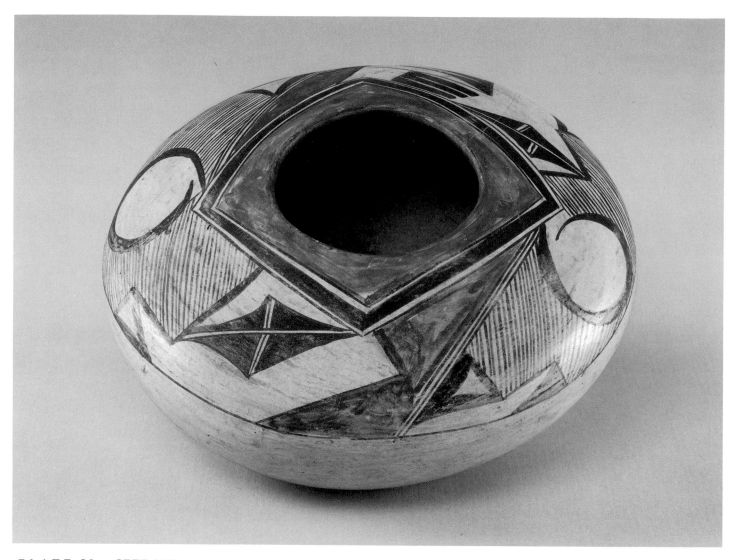

P L A T E 20. SEED JAR, *HOPI, Hano Polychrome, Village of Hano, First Mesa, Arizona. Possibly made by Nampeyo, circa A.D. 1900–1920. Collected by Mary T. McInnes. H. 11.5 D. 22.0 cm (38-27-97). This adaptation of Sikyatki form and design was invented by Nampeyo. Variations of it are still made by members of the Nampeyo family. (Cat. No. 71)*

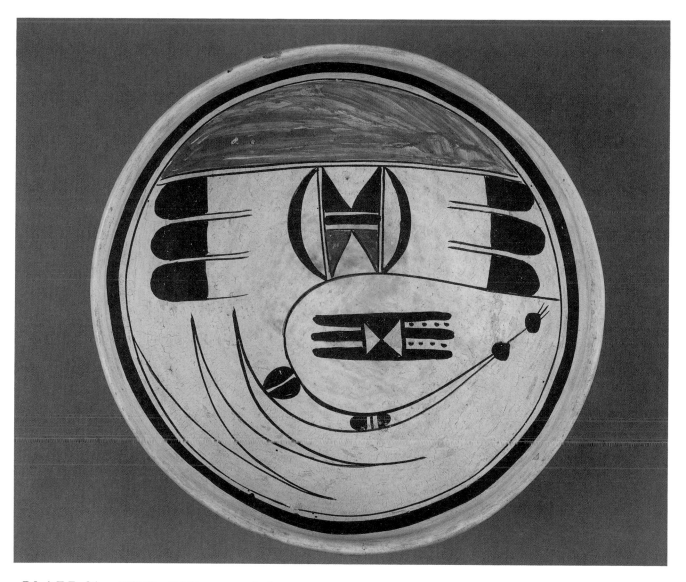

P L A T E 21. BOWL, *HOPI, Hano Polychrome, Village of Hano, First Mesa, Arizona. Made by Nampeyo, circa A.D. 1900. Collected by Mary T. McInnes. H. 9.0 D. 26.0 cm (38-27-98). Nampeyo never signed her work, which is easily confused with that of her daughters. This bowl was collected in the early part of this century, and the dealer's label identifies it as made by Nampeyo. Unlike Sikyatki wares and those made later by Nampeyo, the vessel is covered with a clay slip. (Cat. No. 69)*

with terraced, altar-like crenelations made their first appearance and may have been designed to hold ritual materials.

Designs changed slowly. Bird and feather motifs, and patterning systems that isolated iconic images continued in all areas, with differences in detail from place to place. At some pueblos wide, horizontal framing lines had an open space or "line-break" left in them, apparently for symbolic reasons. There was a progressive loosening of line quality, especially in the Rio Grande glaze paint areas. By mid-seventeenth century in that region, lines that may have been painted with precision would routinely be obscured when the glaze paint fluxed during firing, causing it to bubble, melt, and flow, often at right angles to the original line direction. Changes seemed to be greatest among the eastern pueblos, but even there, aside from the novel soup-plate bowls, there were few overt evidences in pottery of the Hispanic presence, and almost no signs of it are visible in pottery paintings until after the Pueblo Revolt.

The period from 1680 to about 1870 is the least known in the entire history of Anasazi-Pueblo pottery art (Batkin 1987:15–16). The Pueblo Revolt ushered in many changes, beginning with the abandonment of glaze paints wherever they were used and the return to a more tightly controlled linearity. The population losses of previous decades, the movements to refuge sites, and the permanent abandonment of many towns combined to cause a startling reduction in the number of pueblos. With that came a reduced potential for variation in painted pottery styles, and a marked decline in the absolute number of painted vessels and in the quality of painted wares at many places. Vessels were often more crudely made and roughly finished than in the past, and pottery production ended altogether at some communities. Forms changed, sometimes in clear relation to changed diet and social habits. By the beginning of the nineteenth century, many large and small bowls which were often painted only on the exterior were introduced. The former were dough bowls used to make leavened bread; the latter were containers for individual portions of mutton stew. These show the new importance that European foods—wheat and domesticated sheep—now had on the Pueblo diet and economy.

Water jars with indented bases became the dominant form of painted ware in some places, especially at Acoma, and painted variations of the soup-plate bowl became important at Zuni and Hopi Pueblos. A neckless storage jar with a long, conical upper body, low center of gravity, and bulging waist was a common eighteenth-century form. It was replaced by the middle of the nineteenth century with several graceful new shapes.

Lipped, necked jars with a high shoulder and tapering lower body became popular at the northern Rio Grande pueblos. More bulbous or globular variations, often with no lip and no clearly defined neck, were made at the southern Keresan and western pueblos.

Perhaps the most radical changes occurred in painted designs. The fundamental themes of the protohistoric period continued. Painted vessels were polychromed, their designs contained within framed horizontal zones that might be divided into panels. The shape and proportion of design zones and panels were structured in relation to the basic vessel form, and the paintings within them were dominated by large motifs, especially abstractions of birds and feathers. Line-breaks were common on upper and lower framing lines. New configurations appeared, largely in response to new shapes and proportions, and new motifs were introduced. Rosettes and other abstract floral forms, inspired to some degree by exposure to Hispanic art, were used throughout the Pueblo world during the eighteenth and early nineteenth century. By the mid-nineteenth century many European elements, not all of Hispanic origin, had been adopted, especially among the eastern pueblos. Many more botanical motifs including horizontal, flowing, vine-like forms, oak leaves, acanthus leaves, and tulips were now in use as well as birds, animals, and curious, even bizarre, little figures. In some cases similarity of these introduced motifs to Anasazi and Pueblo ritual and social iconography was so strong that the reinterpretation of a European floral rosette as a Pueblo sun symbol, or of a thick-billed bird as emblematic of the Parrot or Macaw Clan, almost could have been predicted.

The high, upper bodies of large storage jars provided the potential for a singularly large design field that was sometimes treated as a single picture space and sometimes divided into two or even three large panels. Variations in the treatment of these large fields came to typify regional decorative styles whose distribution responded at times to historical events and social alliances. For example, one eighteenth century variation, isolating large emblems on a blank field, was favored by the western Tewas and northern Keresans, while another, which filled a field with design elements, was favored by the southern Keresans and the Zuni. After 1800 the latter variation heralded a return at Zia, Acoma, Laguna, and Zuni to earlier Anasazi modes of filling space with linear patterns. At the same time, water jars produced at Zia, Acoma, and Laguna shared unique formal and proportional attributes. The potters at these villages developed a concern for utilitarian craft qualities that still holds at Zia and Acoma.

By the early nineteenth century pottery designs of the southern Keresan and western Pueblos were distinctly different from those of the northern Rio Grande. Bold and colorful

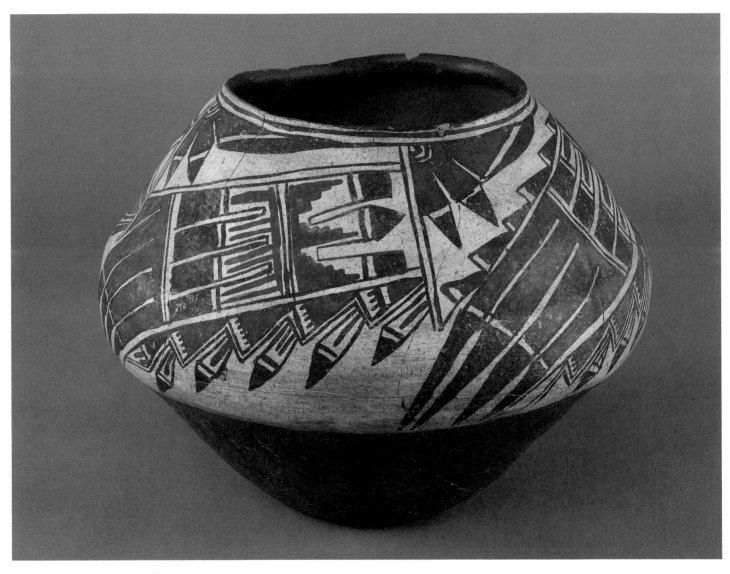

P L A T E 22. JAR (Olla), *Ashiwi Polychrome, Zuni or Acoma Pueblo, New Mexico, circa A.D. 1700–1750. Collected by José Rafael Olquin in 1891. Purchased by Reverend J.M. Whitlock in 1911. H. 24.0 D. 29.0 cm (NA 2167). This rare jar was found in a Navajo region where Pueblo people took refuge after the 1680 Pueblo Revolt. The bulging midriff, stylized feathers forming a diagonal bird wing, large design field, and colors are typical of pottery made in the eighteenth century. These characteristics derive from later prehistoric styles that were unknown when the jar was found in 1891. (Cat. No. 75)*

floral and bird motifs were now integrated into the Acoma-Laguna decorative system, perhaps by way of Zia Pueblo. But the alien-inspired birds and animals painted at the three southern Keresan towns are usually framed within sinuous, snake-like rainbows, as though captured and caged by Pueblo ritual iconography. By early in the twentieth century these design affiliations had ended; the pottery of Acoma and Zia became more and more differentiated while production at Laguna dwindled to a trickle.

Pueblo III designs that are unique to the Cibola region were revived at Zuni before the beginning of the nineteenth century, and at Acoma and Laguna by about 1850. On a very fundamental level, Zuni potters preferred hachured lines to densely filled areas, and so carried forward the ancient Chaco-Cibola linear aesthetic traditions (Bunzel 1929:13–29). As well as designs and aesthetic attitudes from their own past, Zuni potters also adopted motifs from Hispanic sources, especially flower-like rosettes which they integrated into their own system. Ideas from Zuni were adopted by potters of Hopi, Acoma, Laguna, and Zia by the mid-nineteenth century, and ultimately spread to most Rio Grande communities.

By the 1870s at Hopi, motifs derived from the sacred realm, especially images of the kachinas, were routinely used on pottery made for trade to the tourist market as well as for home use. There, and at Zuni, some vessels and the designs on them could also be considered sacred, as when feathers painted on pots are visual prayers, the women's equivalent of prayer plumes that are ordinarily made by men and planted on shrines (Stephen *in* Wade and McChesney 1980). The speed with which the Sikyatki revival spread amongst Hopi-Tewa and Hopi potters late in the nineteenth and early in the twentieth century is evidence that the Hopi artists were ready to renew an ancient iconography that was loaded with images of the sacred.

CONCLUSION

The distribution of designs as well as forms and craft values were expressions of political and social history. The distinctive Hopi pictorial tradition that had slowly evolved since the fifteenth century disappeared during the eighteenth century, buried by waves of Rio Grande and, later, Zuni influences. Acoma, whose painted pottery had been all but identical with that of Zuni from Anasazi times through the eighteenth century had, by early in the nineteenth century, realigned itself with Laguna and Zia to create a southern Keresan style that is quite different from both that of Zuni and the northern

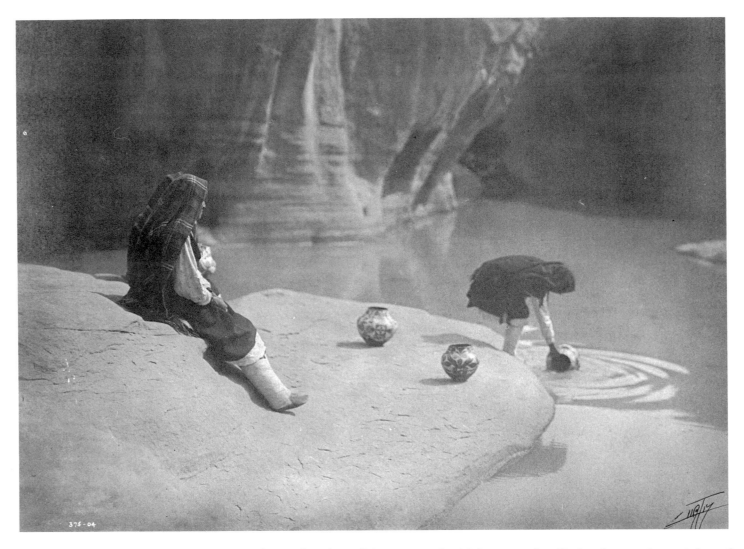

FIGURE 16. *"At the old well of Acoma."* Photograph by Edward S. Curtis, 1904. (neg. S4-139819)

Keresans. The regional traditions out of which came the distinctive modern styles of individual pueblos were in place by the middle of the nineteenth century.

The fact that Pueblo pottery could be used to distinguish between towns and serve as an ethnic marker made it especially useful when it functioned within the Euro-American world. It became a distinctive indicator enabling students of culture and culture history to perceive differences between groups of very similar peoples, and provided a means to

classify and symbolize those differences. Its value as a curio to more casual collectors is equally important. Pueblo pots were souvenirs that a knowledgeable person identified with particular exotic places and people. They were tangible evidence of difficult and interesting journeys to such out-of-the-way places as Zuni and Hopi Pueblos. Vessels that were easily recognized as being from one pueblo rather than another were far more desirable than those that were only generically "Pueblo."

If such souvenirs could also be related to positive social values by virtue of their artistic quality, inherent utility, or by association with admirable moral or ethical concerns, so much the better. Pueblo pottery fit very nicely in many respects with the ethical values and concerns of the arts-and-crafts movements that were a persistent feature of intellectual life in all parts of the industrial world during the latter half of the nineteenth century. It was useful, decorative, handcrafted, and the product of a life-way that might be perceived as pre-industrially virtuous, unselfish, harmonious, communal, and perhaps closer to divinity than that of modern urban peoples. Transformation of the original values and utilities of these objects by their new possessors was easily achieved, and they could also become art objects in the industrial world.

But Pueblo pottery is more than art, or curio, or scientific specimen. Water kept in pottery jars takes on a distinctive earthy flavor, its taste is evocative of the critical physical and spiritual values that water has in the arid lands of the Pueblo people (Fig. 16). Pottery jars may be thought of as clouds holding water: when a jar breaks people are expected to ". . . rejoice and say 'let it rain' " (Museum of the Pueblo of Acoma n. d.). A Pueblo potter today may give especially fine vessels to members of her family to be used at naming ceremonies or to be kept through life and buried with them when they die. By mid-nineteenth century, regardless of motifs and their origins, irrespective of how their pottery was to be used, or by whom, the potters of Zuni, Acoma, Laguna, and Zia had begun to compose the paintings on their water jars much as their Anasazi forebears had, with linear arrangements that fused foreground and background into a seamless harmony (Bunzel 1929:29–38). Shortly afterwards Hopi potters and those of the Rio Grande pueblos also found inspiration in Anasazi design systems. The very structure of their pottery paintings were now statements of unity, continuity, and harmony, and these useful objects of beauty made from the earth became metaphorical bridges across chasms of time, space, and diverse cultural values.

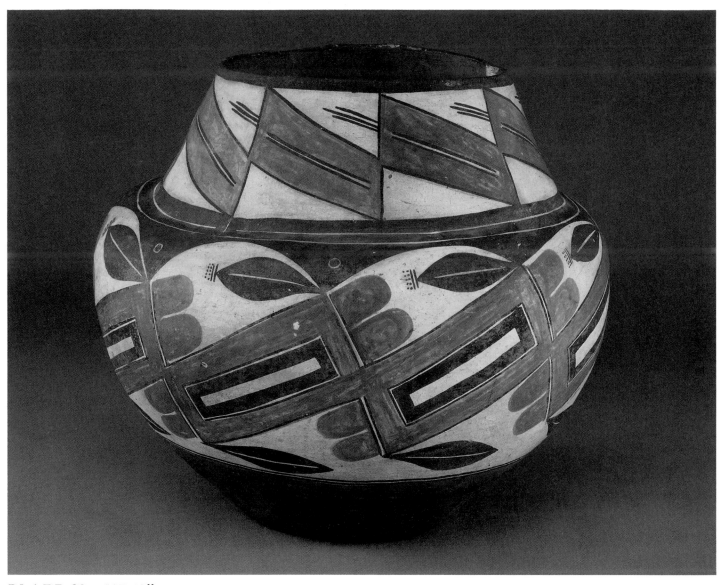

PLATE 23. JAR (Olla), *Acoma Polychrome, Acoma Pueblo, New Mexico, circa A.D. 1880–1890. Collected by Charles H. Stephens and purchased from his children in 1945. H. 27.0 D. 29.0 cm (45-15-101). This light, strong, beautifully crafted vessel is a typical water jar of the period. The bold diagonals recall the eighteenth century Ashiwi style (see Cat. No. 75), and the painting is a complex of motifs that seem to summarize the history of pottery painting at Acoma Pueblo. (Cat. No. 76)*

REFERENCES

Bandelier, Adolf E.

1971 *The Delight Makers.* New York: Harcourt Brace Jovanovich (originally published 1890).

Batkin, Jonathan

1987 *Pottery of the Pueblos of New Mexico: 1700–1900.* Colorado Springs: Taylor Museum and Colorado Springs Fine Arts Center.

Brew, J.O.

1979 "Hopi History and Prehistory." In *Handbook of North American Indians.* Vol. 9, *The Southwest,* ed. Alfonso Ortiz, pp. 514–523. Washington, D.C.: The Smithsonian Institution.

Brody, J.J.

1977 *Mimbres Painted Pottery.* Albuquerque: University of New Mexico Press.

1990 *The Anasazi.* New York: Rizzoli.

Bunzel, Ruth

1929 *The Pueblo Potter: A Study of Creative Imagination in Primitive Art.* New York: Columbia University Press.

Carlson, Roy L.

1970 "White Mountain Redwares, A Pottery Tradition of East-Central Arizona and Western New Mexico." *Anthropological Papers of the University of Arizona,* 19. Tucson.

Cordell, Linda S.

1984 *Prehistory of the Southwest.* Orlando, FL: Academic Press.

Dittert, Alfred E., Jr., and Fred Plog

1980 *Generations in Clay: Pueblo Pottery of the American Southwest.* Flagstaff: Northland Press.

Donaldson, Thomas C.

1893 "Moqui Pueblo Indians of Arizona and Pueblo Indians of New Mexico." *Eleventh Census of the United States.* Washington, D.C.: United States Census Printing Office.

Ellis, Florence H.

1979 "Laguna Pueblo." In *Handbook of North American Indians.* Vol. 9, *The Southwest,* ed. Alfonso Ortiz, pp. 438–449. Washington, D.C.: The Smithsonian Institution.

Ferguson, William M., and Arthur H. Rohn

1986 *Anasazi Ruins of the Southwest in Color.* Albuquerque: University of New Mexico Press.

Garcia-Mason, Velma

1979 "Acoma Pueblo." In *Handbook of North American Indians.* Vol. 9, *The Southwest,* ed. Alfonso Ortiz, pp. 450–466. Washington, D.C.: The Smithsonian Institution.

Hammond, George P., and Agopito Rey, eds.

1966 *The Rediscovery of New Mexico, 1580–1594.* Albuquerque: University of New Mexico Press.

Hardin, Margaret Ann

1983 *Gifts of Mother Earth: Ceramics in the Zuni Tradition.* Phoenix: The Heard Museum.

Hoebel, E. Adamson

1979 "Zia Pueblo." In *Handbook of North American Indians.* Vol. 9, *The Southwest,* ed. Alfonso Ortiz, pp. 407–417. Washington, D.C.: The Smithsonian Institution.

Sando, Joe S.

1979 "The Pueblo Revolt." In *Handbook of North American Indians.* Vol. 9, *The Southwest,* ed. Alfonso Ortiz, pp. 194–197. Washington, D.C.: The Smithsonian Institution.

1982 *Nee Hemish: A History of Jemez Pueblo.* Albuquerque: University of New Mexico Press.

Schroeder, Albert H.

1979 "Pueblos Abandoned in Historic Times." In *Handbook of North American Indians.* Vol. 9, *The Southwest,* ed. Alfonso Ortiz, pp. 236–254. Washington, D.C.: The Smithsonian Institution.

Simmons, Marc

1979a "History of Pueblo-Spanish Relations to 1821." In *Handbook of North American Indians.* Vol. 9, *The Southwest,* ed. Alfonso Ortiz, pp. 178–193. Washington, D.C.: The Smithsonian Institution.

1979b "History of the Pueblos Since 1821." In *Handbook of North American Indians.* Vol. 9, *The Southwest,* ed. Alfonzo Ortiz, pp. 206–223. Washington, D.C.: The Smithsonian Institution.

Stanislawski, Michael B.

1979 "Hopi-Tewa." In *Handbook of North American Indians.* Vol. 9, *The Southwest,* ed. Alfonso Ortiz, pp. 587–602. Washington, D.C.: The Smithsonian Institution.

Stevenson, James

1883 "Illustrated Catalogue of the Collections Obtained from the Indians of New Mexico and Arizona in 1879." *Second Annual Report of the Bureau of Ethnology to the Secretary of the Smithsonian Institution. 1880–'81,* pp. 307–422. Washington, D.C.

Underhill, Ruth

1944 *Pueblo Crafts,* Washington, D.C.: U.S. Bureau of Indian Affairs.

Wade, Edwin L., and Lea S. McChesney

1980 *America's Great Lost Expedition: The Thomas Keam Collection of Hopi Pottery from the Second Hemenway Expedition, 1880–1894.* Phoenix: The Heard Museum.

1981 *Historic Hopi Ceramics: The Thomas V. Keam Collection of the Peabody Museum of Archaeology and Ethnology, Harvard University.* Cambridge: Peabody Museum Press.

SUGGESTED READING

Brody, J.J.

1988 "Anasazi Pottery of the American Southwest." *Antiques* 134(3):494–511.

Fane, Diana

1986 "Curator's Choice: Indian Pottery of the American Southwest." *American Indian Art Magazine.* 11(2):46–53.

Frank, Larry, and Francis H. Harlow

1974 *Historic Pottery of the Pueblo Indians: 1600–1880.* Boston: New York Graphic Society.

Harlow, Francis H.

1973 *Matte-Paint Pottery of the Tewa, Keres, and Zuni Pueblos.* Santa Fe: Museum of New Mexico.

Ortiz, Alfonso, ed.

1979 *Handbook of North American Indians.* Vol. 9, *The Southwest.* Washington: The Smithsonian Institution.

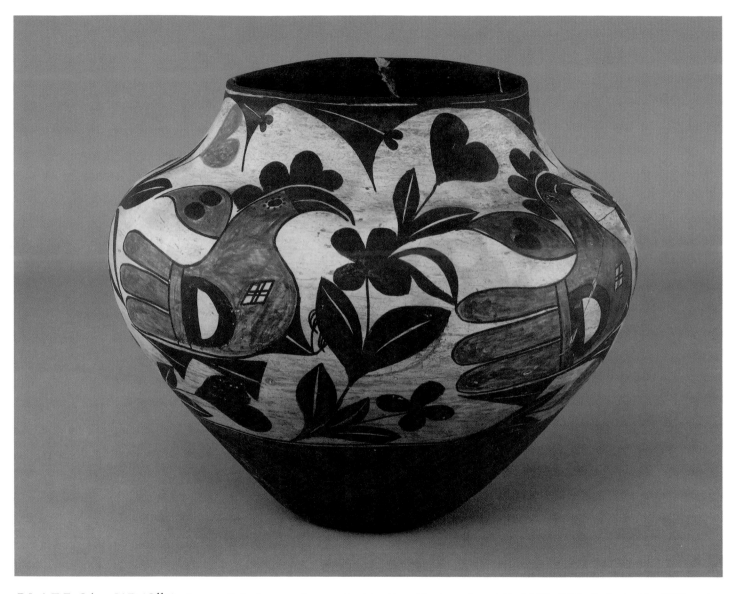

PLATE 24. JAR (Olla), *Acoma Polychrome, Acoma Pueblo, New Mexico, circa A.D. 1880–1900. Collected by William T. Anderson. H. 29.0 D. 31.0 cm (86-20-32). This jar's parrot motifs, similar to those painted by women on the church walls at both Acoma and Laguna Pueblos, as well as the floral motifs, were inspired by European designs. The triangles below the rim are variations of a butterfly design used at the western pueblos since the fifteenth century. (Cat. No. 77)*

POTTERY TECHNOLOGY

J.J. Brody

Pueblo people, as had their Anasazi ancestors, hand-build their pottery. Modern potters mine and refine their clay using the same techniques and often the same clay deposits as their ancestors.

Clay is dug from pits, often by family work parties, cleaned, and ground to a fine powder in a stone mortar (*metate*) with a hand-grinding stone (*mano*). The powder is soaked in water, aged, and then the fine sediments are removed, mixed with temper, and balls of clay large enough to make the desired vessels are kneaded to the right consistency.

The vessels are formed by using rope-like coils of clay (Fig. 17). Today, large vessels are usually started by pressing a sheet of clay into a pottery base mold (A); this is turned as the vessel is formed by adding clay coils which are pressed and scraped together (B). When the desired wall height is reached the partially dried vessel is thinned and shaped with carved gourd rinds (C and D). The surface to be painted is then coated with slip and polished with a smooth, wet polishing stone which is highly valued and may be inherited. Paint is applied with brushes made of chewed yucca leaves, and the finished piece is set aside to dry. Pottery that is not painted is often given a textured surface instead. Well-dried vessels are fired outdoors in a carefully prepared shallow pit where they are

FIGURE 17. *Steps in forming an Anasazi or Pueblo vessel (adapted from Underhill 1944).*

A

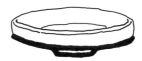

B

protected from direct contact with burning fuel by large potsherds or sheets of metal. Dried cow or sheep dung is the usual fuel today, but the Anasazi used wood, coal and perhaps dried corn cobs.

Many different clays were used by the Anasazi and are used today at the various pueblos. Some are fired red, some gray, some white. Most require the use of a non-plastic temper, and tempering materials range from sand to crushed pottery sherds, basalt and other hard, black rocks, to pumice and powdered volcanic ash. Local preferences were and still are important and persistent. The late Pueblo IV southern Keresans used a dense, red-firing clay with crushed basalt-like temper, and their Zia descendants still use the same materials. Their close ethnic neighbors at Santa Ana Pueblo shifted to use of a sand temper during the eighteenth century when they moved about fifteen miles eastward to the Rio Grande. As early as the fifteenth century, yellow slips were sometimes used by Rio Grande potters on their red or gray paste pottery in apparent emulation of yellow Hopi wares.

Hopi potters mine their distinctive clay from several different locations. It is a fine kaolin that requires little or no tempering to control shrinkage and cracking, and it fires to a yellow color at temperatures that are generally higher than those reached at the other pueblos. If temper is added it is virtually invisible, made of finely ground fired slabs of the same clay. From Pueblo IV times, when those clay mines were first exploited, until late in the eighteenth century, Hopi painted vessels were not slipped. Instead their surfaces were polished, sometimes to satin smoothness before they were painted and fired.

The Rio Grande emigrants to Hopi influenced radical changes in the character of Hopi pottery. Eighteenth-century Hopi vessels took on a Rio Grande appearance in form and proportion, and Rio Grande designs, including motifs of Hispanic origin, came into common use (Wade and McChesney 1981). Hopi clay was less finely processed, firing temperatures were lower, and polished surfaces were not as smooth as in the past. From the end of the eighteenth century until early in the twentieth century, the paste used to make the Hopi vessels became decidedly coarse and was sand-tempered and granular. Areas to be painted were now slipped with a yellow clay that often left a crackled surface.

No other Anasazi or Pueblo people had access to clay like that of the Hopi, and there is no mistaking the ancient Hopi wares, even when they are reduced to sherds. In the Cibola region, the clays available to the Zuni, Acoma, and Laguna potters were coarser and shrank and cracked if left untempered. From earliest times until the present, Cibola painted wares were tempered with crushed sherds of broken pottery often collected at

ancient sites. Perhaps for that reason, these pueblos seem to be the ones most aware of ancient Anasazi black-on-white traditions.

Cibola clays fire to a whitish-gray color and require several applications of a fine slip if the painting surface is to acquire the smooth, polished quality that was usually preferred. At Zuni for the last century most, perhaps all, potters get their clay from a single mesa. The clay pits seem to be community property, a "gift of Mother Earth" to be treated with respect and at times with ceremony that may exclude men from participation in this women's art. Here also, as at Hopi, painted feathers may be women's prayers (Hardin 1983; Bunzel 1929:69–70).

Acoma and Laguna potters get their clay from many sources, some of which are as distant as Chaco Canyon, and at least some clay beds are considered family property. In these pueblos also the clay has something of a sacred character and, at least in recent times, pottery vessels may also embody mystical qualities.

Those eastern Keresan people who took refuge at Acoma and then formed Laguna Pueblo adopted Acoma pottery-making materials, methods, and decorative principals. Their wares are visually indistinguishable from those of Acoma—the texture of their clay is said to be a bit denser and more likely to include sand with the sherd temper, and their painted lines may be somewhat thicker and darker (Batkin 1987:149–150).

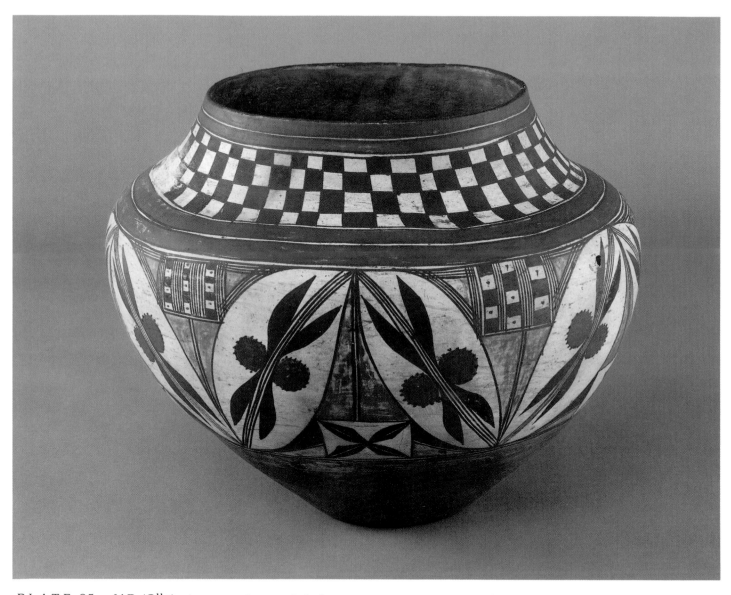

P L A T E 25. JAR (Olla), *Acoma or Laguna Polychrome, Acoma or Laguna Pueblo, New Mexico, circa A.D. 1880–1900. Collected by Charles H. Stephens and purchased from his children in 1945. H. 25.0 D. 34.0 cm (45-15-102). The heavy bands and general darkness of the painting on this water jar suggest that it was made at Laguna Pueblo. The painting contains many Anasazi elements, and the flower-berry motif of European origin can also be interpreted as a flying insect. (Cat. No. 85)*

THE HISTORY OF THE UNIVERSITY MUSEUM'S SOUTHWESTERN POTTERY COLLECTION

Rebecca Allen

People have the impression that museum collections, like museum exhibits, "just happen," but museum collections are formed in a variety of ways . . . the decisions of all previous generations of collectors affect what is available as potential research data today.

Parezo 1987:2–3

Both systematic collection and accidents of history helped form the southwestern pottery collection at The University Museum of Archaeology and Anthropology. More than 3500 pieces of prehistoric and historic Pueblo pottery are housed in the Museum — the result of scholarly expeditions and generous contributions by many individuals. Names of families such as Wanamaker, Hearst, and Wetherill, and of institutions such as the Academy of Natural Sciences of Philadelphia and The Field Museum of Natural History in Chicago are all part of the story of how the Museum collection grew from its inception at the turn of the century until the present time.

The potential of this pottery for archaeological and ethnographic research is rich. The value of the pieces to scholars is dependent on the amount of documentation supplied by the collector. This information is sometimes comprehensive, but it is in many instances inadequate, a shortcoming that was not always the fault of the collectors, for they were often purchasing pieces second- or third-hand. The contributions of the collectors naturally reflect their personal tastes and sensibilities, thus affecting the collection as a source of data.

The time period covered by The University Museum's collection reveals an aspect of prehistoric and historic Pueblo cultures and aesthetic values specific to their traditions. Later additions also show the foreign aesthetic tradition of the Euro-American tourists, who frequented the Southwest after the coming of the railroad in 1880, and, in their role as consumers, influenced Pueblo pottery-making. These changes in style and function are well represented by the diversity of the ceramics housed in The University Museum.

THE HAZZARD-HEARST COLLECTION

Mrs. Phoebe Hearst provided the funds to purchase the first large collection of southwestern artifacts for The University Museum. This material had originally been assembled from three sources by C.D. Hazzard, who was associated with the H. Jay Smith Exploring Company. Hazzard purchased a large number of artifacts gathered by the Wetherill brothers in the Mesa Verde area of Colorado in 1889–1892 (Fig. 18). The Wetherills were the sons of Benjamin Kite Wetherill, a Pennsylvania Quaker from the

FIGURE 18. *Cave No. 7 in Grand Gulch, Utah. The Wetherill excavation crew, including Al Wetherill (fourth from left). Photograph probably taken by Richard Wetherill in 1893.*

FIGURE 19. *Battle Rock of McElmo Canyon, constructed to display the collections of the H. Jay Smith Exploring Company at the World's Columbian Exposition in Chicago, 1893. Courtesy of the New York Public Library. (neg. S4-139880)*

Chester County region, who moved his family west and established a farming ranch in the Four Corners area near Mancos, Colorado, at the foot of Mesa Verde. His sons, most notably Richard Wetherill, took an interest in the ancient cliff dwellings they encountered while herding cattle. Four collections made by the Wetherill brothers in Mesa Verde between the years 1889 and 1892 were deposited in public museums—the Denver Historical Society, The University Museum, the National Museum in Finland, and the Colorado State Museum. The activity of the Wetherills remains controversial because their excavation techniques, by modern standards, were unscientific and akin to "pothunting." Their techniques, especially Richard's, improved after 1891 when a Swedish scientist, Gustaf Nordenskiöld, excavated with the brothers and made detailed notes of the excavation, an example the Wetherills followed thereafter (Lister and Lister

1985:153). The artifacts from this excavation were sent to Sweden and were eventually deposited in the National Museum of Finland. The collection purchased by Hazzard was made, for the most part, before Nordenskiöld's visit and is therefore not well provenienced.

A second collection purchased by Hazzard was assembled by C.M. Viets, a private collector who gathered prehistoric southwestern materials from the Cortez, Colorado, area. Hazzard exhibited both the Viets and the Wetherill collections on the midway of the 1893 Chicago World's Columbian Exposition in a building shaped to resemble a cliff in the Southwest desert (Fig. 19), complete with great murals inside the cliff houses (McNitt 1957:327). The intent of the H. Jay Smith Exploring Company was to make a profit by charging 25¢ a head, while introducing to the world a little-known, "primitive" group:

> They are a mythical race, exhibiting in the relics found, rare powers and refined tastes at variance with the common idea of aborigines (Smith Exploring Company 1893:1).

In addition to pottery, the collection included many other "relics" of prehistoric southwestern Indians—mummies, clothing, sandals, stone tools, baskets, plant remains, and agricultural tools. The prehistoric Pueblo pottery, however, was one of the focal points of the Columbian Exposition, and three of the outstanding pieces mentioned are described in the catalogue as follows:

> On one vase a Cliff Dweller is seen hunting deer with bow and arrows; on a drinking vessel the picture of a dancing figure is represented, while on another turkeys ornament the handle of a drinking cup (Smith Exploring Company 1893:17).

These descriptions almost certainly refer to pieces included in this catalogue (Cat. Nos. 28, 36, 31).

Hazzard later purchased a portion of a collection amassed by Reverend C.H. Green. Green had previously bought the materials from the men who unearthed the artifacts in Grand Gulch, Utah in 1891–1892—John Wetherill, Wash and Levi Patrick, Charles McLoyd, and Howard and Charles Graham. In 1893, in competition with the Columbian Exposition, Green exhibited his collection at the Art Institute of Chicago, creating a sensation and generating speculation about the Cliff Dwellers of New Mexico and Arizona. One New York journalist was even inspired to write an article postulating that North America had been the "cradle of the human race" (Green 1893:26).

After the Columbian Exposition, Hazzard stored all three collections in a Chicago warehouse and unsuccessfully attempted to sell them (McNitt 1957:33). Hector Alliot, an

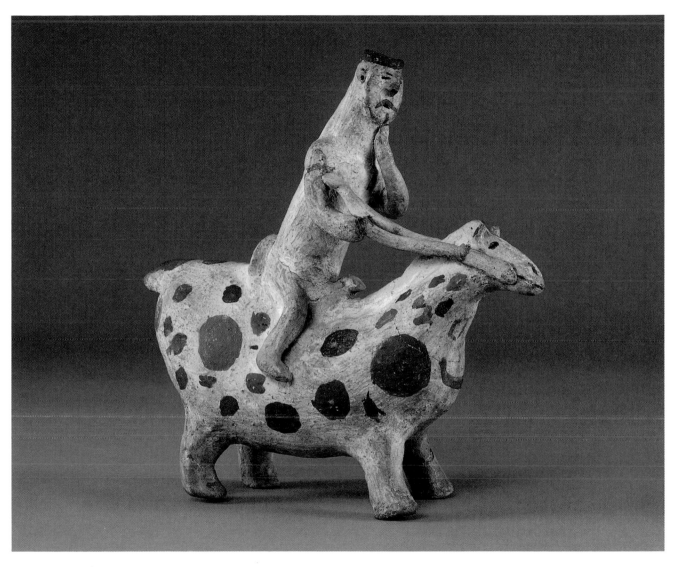

P L A T E 26. FIGURINE, *Acoma Polychrome, Acoma Pueblo, New Mexico, circa A.D. 1890. Collected by Thomas C. Donaldson between 1890–1893. H. 19.0 D. 20.2 cm (38012). Although there is no doubt that this ceramic horseman was made as a tourist market curio, it comes out of an old Pueblo pottery tradition. Figurines were (and are today) made by Anasazi and Pueblo potters for many uses including toys, fun, games, and ritual. (Cat. No. 78)*

agent for Hazzard, approached Stewart Culin (Fig. 20), first director of The University Museum (at that time called the Museum of Archaeology and Palaeontology of the University of Pennsylvania), about the possibility of purchasing the collection for the Museum. The price was ''$25,000, that is $2.50 per specimen'' (Alliot to Culin). In April of 1895, after lengthy negotiations, the collection was sent to The University Museum with the agreement that it would be on loan for two years. If after one year a decision to purchase at the reduced price of $15,000 had not been reached, it could be offered to another institution (Agreement between Hazzard and the Department of Archaeology).

Culin was eager to exhibit the pottery. He wrote to his friend and colleague, Frank Hamilton Cushing, asking him to provide background information on the Cliff Dwellers and this collection in particular (Fig. 21). Cushing, a well-known ethnologist with the Bureau of American Ethnology who had spent almost five years in New Mexico studying

FIGURE 22. *Illustration from newspaper article "With Western Mummies: A Glimpse of Some of the Wonders of Cliff Dwellers' Relics,"* Philadelphia Record, *November 10, 1895. (neg. S4-139879)*

and living among the Zuni, replied that Culin had "special abilities" of his own in label writing. Nevertheless, Cushing sent notes on the Indians of the Southwest—their "general characteristics and values"—and more specific information on basketry, textiles, and pottery (Cushing to Culin). His remarks on pottery include his notion of the development of ceramics from the earlier craft of basketry.

> The Pottery of the collections although resulting from a period of many centuries of development out of the first crude and stitch pinched baskets of clay in which it began, still retains even in the latest painted and finely moulded forms, the traces of its basketry origin. . . . Thus too, the ornaments in paint line and even added figure devices of symbolic purpose on the latest food jar and water vases retain such of the art character to be found in the basketry and textile designs (Cushing to Culin).

Cushing was interested in documenting and confirming his theory of the similar origins of all cultures, and the materials gathered by Hazzard interested him because of their variety and abundance. In November of 1895 an exhibition of these materials, enhanced by Cushing's labels, opened at the Museum. Lectures by Cushing, Culin, and other scholars on southwestern prehistory, history, and the study of anthropology in general were presented at the exhibition's opening (Fig. 22). The local press wrote favorable

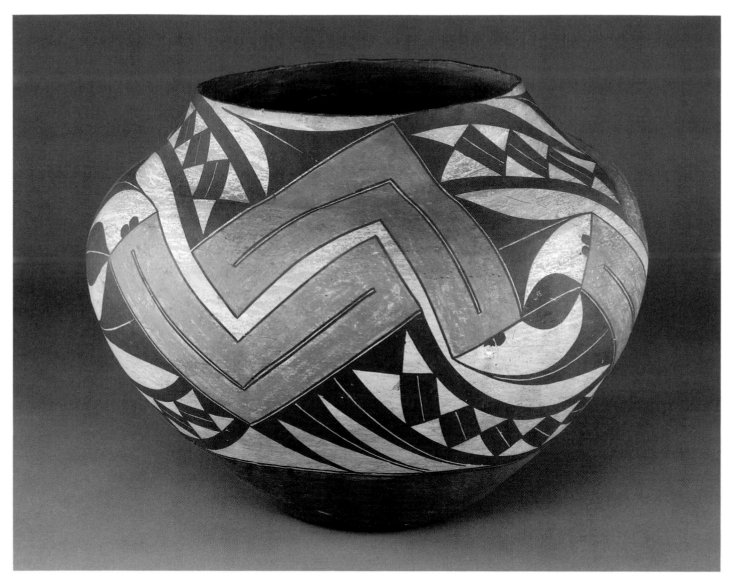

P L A T E 27. JAR (Olla), *Acoma Polychrome, Acoma Pueblo, New Mexico, circa A.D. 1890–1910. Gift of Stephen B. Luce. H. 25.0 D. 32.0 cm (47-1-2). The sweeping, wave-like boldness of this jar's central design does not disguise the many Anasazi revival elements that are also present. Careful observation reveals ambiguous figure-ground inversions, and bird, feather, and floral abstractions. (Cat. No. 81)*

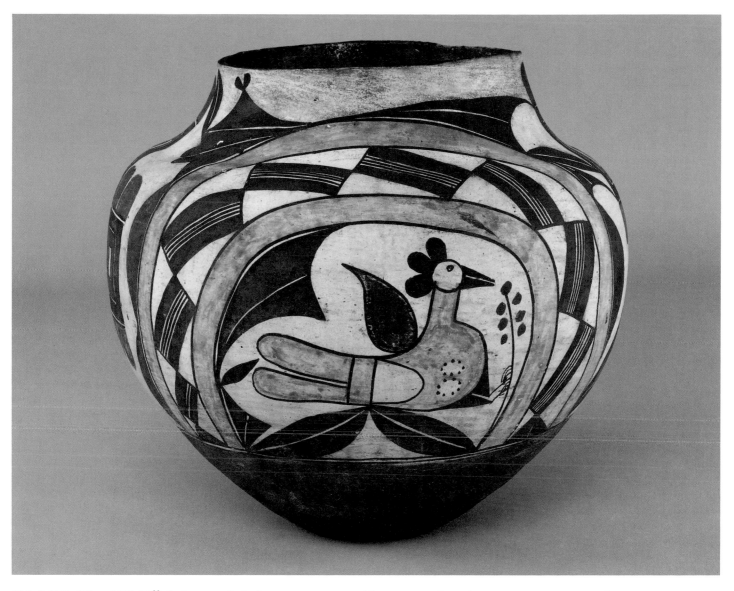

P L A T E 28. JAR (Olla), *Laguna Polychrome, Laguna Pueblo, New Mexico, circa A.D. 1880–1900. Collected by Charles H. Stephens and purchased from his children in 1945. H. 31.0 D. 32.5 cm (45-15-103). This jar's bird and floral motifs may come from European designs, but the black-on-white rectangles are of Anasazi origin. The frame around the bird is a variant of a "rainbow" frame, common also at Zia and Acoma Pueblos and a very old theme in ritual art. (Cat. No. 86)*

reviews on the exhibit of ancient mummies of the Cliff Dwellers that were displayed along with their household, agricultural, and warfare implements (*Philadelphia Times*, Nov. 10, 1895).

Almost immediately Culin set about trying to find the necessary funds to purchase what he described as "the largest and most perfect collection of cliff-dweller material in existence" (*Philadelphia Record*, Nov. 10, 1895). He approached Dr. William Pepper, Jr., President of the Museum's Board of Managers, who in turn solicited the help of Mrs. Phoebe Hearst, a well-known philanthropist, mother of William Randolph Hearst, and a personal friend of Pepper's. At his urging, she agreed to send Hazzard $14,500 for the collection. In a terse note she confirmed her decision:

> Notify Mr. Hazzard on March 1 that Mrs. P.A. Hearst has agreed to by [sic] the Hazzard collection for the Museum . . . that payments will be made about April 1: Jul 1: October 1, 1896 (Hearst).

The offer was accepted by Hazzard and an agreement was signed on February 7, 1896.

In 1901 Mrs. Hearst requested that 288 artifacts from the collection be given to the Lowie Museum of Anthropology at the University of California, Berkeley. The majority of the collection, however, remained at The University Museum. With the acquisition of the Hazzard-Hearst collection, the Museum began to build its southwestern holdings.

THE DONALDSON COLLECTION

In July of 1901 Culin purchased a second large collection of southwestern materials for The University Museum. This time funds were provided by John Wanamaker, the Philadelphia department store founder. The collection was assembled by Thomas Corwin Donaldson of Philadelphia between 1890–1893 when he traveled through the Southwest as an "Expert Special Agent of the Eleventh Census of the United States" (Fig. 23).

Donaldson made many notes on the countryside and his surroundings as he gathered census information. He was fascinated by the Indian people and collected pottery and other materials in use from the Pueblos and their neighbors—the Navajo, Apache, Yuma, and Pimans. He also acquired prehistoric vessels that the Indians themselves collected and kept in their homes. At Zuni he found a miniature Anasazi seed jar and pitcher (Figs. 24 and 25). Some of the contemporary pieces he collected were trade items from

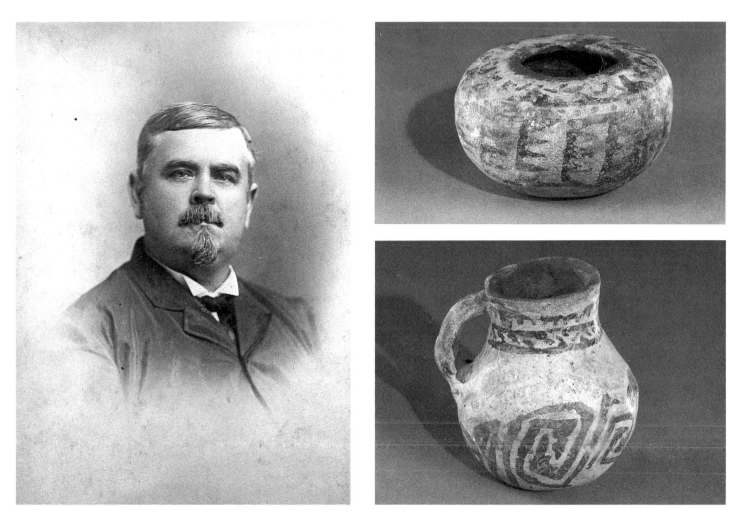

FIGURE 23. (Left) *Thomas C. Donaldson. Photograph by C.M. Bell. (neg. S4-139873)*

FIGURE 24. (Top Right) *Miniature seed jar, Anasazi, Kayenta Black-on-white. Collected by Thomas C. Donaldson at Zuni Pueblo between 1890-1893. (Cat. No. 43)*

FIGURE 25. (Bottom Right) *Miniature pitcher, Anasazi, Kayenta Black-on-white. Collected by Thomas C. Donaldson at Zuni Pueblo between 1890-1893. (Cat. No. 42)*

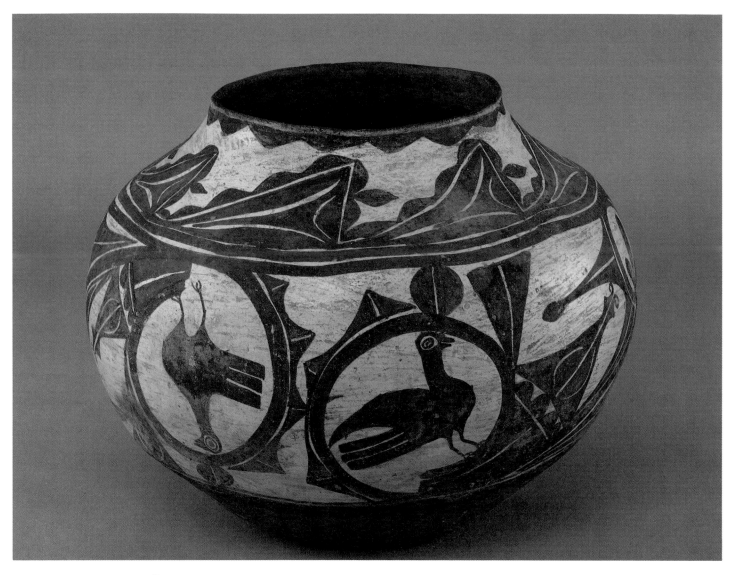

PLATE 29. JAR (Olla), *Zia Polychrome, Zia Pueblo, New Mexico, circa A.D. 1880–1890. Collected by Thomas C. Donaldson between 1890–1893 at Laguna Pueblo, New Mexico. H. 24.0 D. 30.0 cm (38033). Thomas Donaldson acquired this delightful storage jar at Laguna Pueblo. Late nineteenth century Acoma, Laguna, and Zia Pueblo pottery is often very similar, and all reflect influence from nearby Zuni Pueblo. The clay and temper used to construct this vessel indicate that it was made at Zia Pueblo. (Cat. No. 88)*

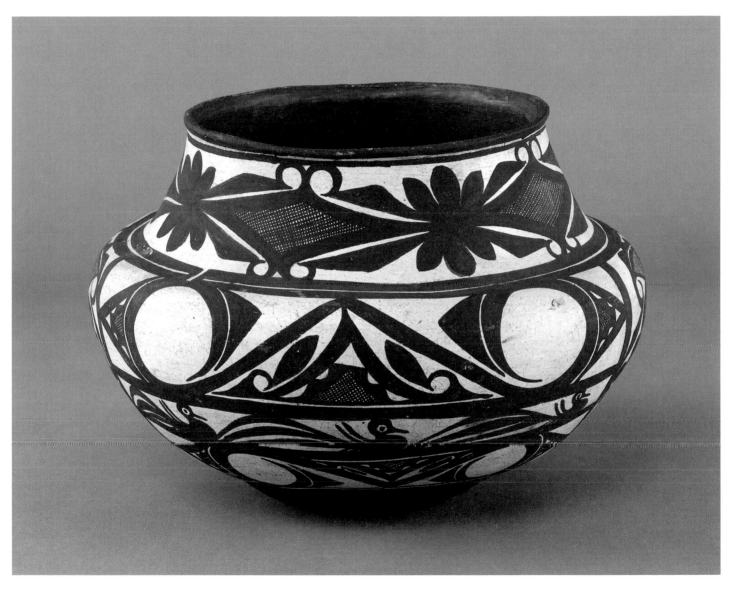

P L A T E 30. JAR (Olla), *Zuni Polychrome, Zuni Pueblo, New Mexico, circa A.D. 1870–1880. Collected by Thomas C. Donaldson between 1890–1893. H. 18.0 D. 24.0 cm (38321). The painting on this jar is darker than Zuni artists usually prefer. Its precise execution and constricted base suggest a date well before 1900. The vessel was formed in a shallow mold that terminated at the point at which the jar begins to balloon outward. (Cat. No. 91)*

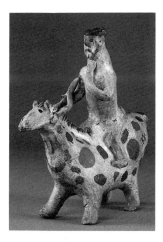

FIGURE 26. *Figurine,*
Acoma Polychrome.
Collected by Thomas C.
Donaldson between
1890-1893. (Cat. No. 78)

neighboring pueblos. Donaldson carefully recorded the pueblos from which he collected these goods.

Like Culin and others of the period, Donaldson shared the nineteenth-century view of cultural evolution. He considered the Pueblo people and their pottery to be attractive but "barbaric." "[T]heir pottery . . . is quaint in form and artistic in decoration, but it is usually primitive, as is general with wild or uncivilized races" (Donaldson 1893:8). He considered the women potters to be skilled artisans but imitative rather than inventive:

> [T]he women of the pueblos are ingenious pottery makers . . . there is an endless variety of the pottery . . . The Pueblo women are great imitators, and they not only decorate their pottery with animals and clouds, but recently . . . they produced a series of figures from a theatrical bill they had seen at Santa Fe . . . (Donaldson 1893:84).

As though to prove his point, Donaldson collected numerous figurines such as a small Acoma horseman (Fig. 26) reflecting his interest in pieces mimicking Euro-Americans. Figurines had long been a part of the tradition of Pueblo pottery, but they proliferated with the development of the tourist market (Babcock, Monthan and Monthan 1986). Donaldson was unique in this interest. Most "serious" collectors considered items made solely for the tourist market not worthy of notice.

After Donaldson's death in 1898, his collection of objects was offered to The University Museum by his son, Thomas Blaine Donaldson, then Secretary, Registrar, and Treasurer of the General Alumni Society of the University of Pennsylvania (Donaldson to Culin). Stewart Culin urged the Museum Board of Managers to make the purchase. It was, in Culin's opinion, "well catalogued and is in admirable condition . . . The acquisition of this collection would place us in possession of much unique material" (Culin to Brock, 1901).

THE WANAMAKER EXPEDITION

Stewart Culin continued to shape the make-up of the southwestern collections. In 1901, he added over 2000 pieces of prehistoric and historic Pueblo pottery to the Museum's holdings. In May of 1900, the first of a series of Museum-sponsored expeditions funded by Wanamaker was sent to the West. Culin, then Curator of the General Ethnology and American Prehistoric Archaeology Sections, wanted to systemat-

ically add to the Museum's archaeological and ethnological holdings. His goal was to establish basic type collections of American Indian material culture. Like many of his peers, Culin felt the pressing need to mount collecting expeditions before the native Indian cultures were assimilated and traditional Indian technologies disappeared. In a letter to a Board member of the Museum, Culin expressed his sense of urgency to go to the Southwest, Plains, and Northwest Coast:

> The Indian is becoming so rapidly civilized or extinct that with the demand from private collections and American and foreign museums, there will soon be nothing left within the reservations (Culin to Brock, 1900).

Culin strongly felt the competition from other museums. In fact, The University Museum was behind in responding to this notion of "salvaging disappearing cultures" (Parezo 1987:20–21). By the mid-1880s, the larger Eastern museums—including the Smithsonian Institution and the Peabody Museum at Harvard University—had already sent out collecting expeditions to the Southwest (Parezo 1987:34).

With money provided by Wanamaker, Culin traveled to Chicago to meet with George Dorsey, Curator of Anthropology at the Field Museum of Natural History (then called the Field Columbian Museum). Because Dorsey had already been on several collecting expeditions, he promised to aid Culin in his quest for Indian artifacts through his established contacts. In May 1900 the two men set out for the Plains and Northwest Coast to assemble collections for their respective museums. Culin established his style of collecting on this expedition. He took very detailed notes and kept extensive diaries (these are today housed in The Brooklyn Museum where Culin was appointed Curator of Ethnology in 1903).

In 1901 Culin traveled through the Southwest collecting archaeological specimens and Hopi ethnographic materials. Culin's method of collecting in the Southwest was to contact traders and dealers. As a result, the strength of the documentation varied. He usually was able to determine and record the pueblo of origin for most of the ethnographic materials, but his information for prehistoric items was less precise and reliable.

The most well-known trader from whom Culin received materials was Thomas Varker Keam. Keam was given a license to trade in Hopi territory in 1875, and he established himself near First Mesa. He traded industrial wares to the Hopi for their handcrafted goods. About 1890 he began to deal in late prehistoric pottery and contemporary ceramics (Brody 1979:604–605). Keam provided Culin with 108 pieces of pottery, mostly

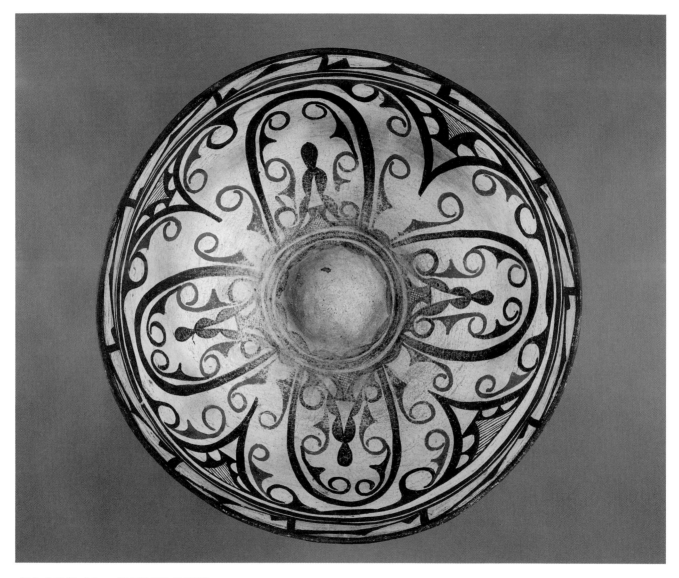

PLATE 31. DOUGH BOWL, *Zuni Polychrome, Zuni Pueblo, New Mexico, circa A.D. 1880–1890. Collector unknown. H. 21.0 D. 47.5 cm (NA 2173). The base of this bowl is deeply indented for comfort when carried on the head. Large dough-mixing bowls were made after leavened bread and wheat were introduced by Europeans. The rim shape and stylized feather designs originated in late prehistoric traditions that may not have been known when this vessel was made. (Cat. No. 93)*

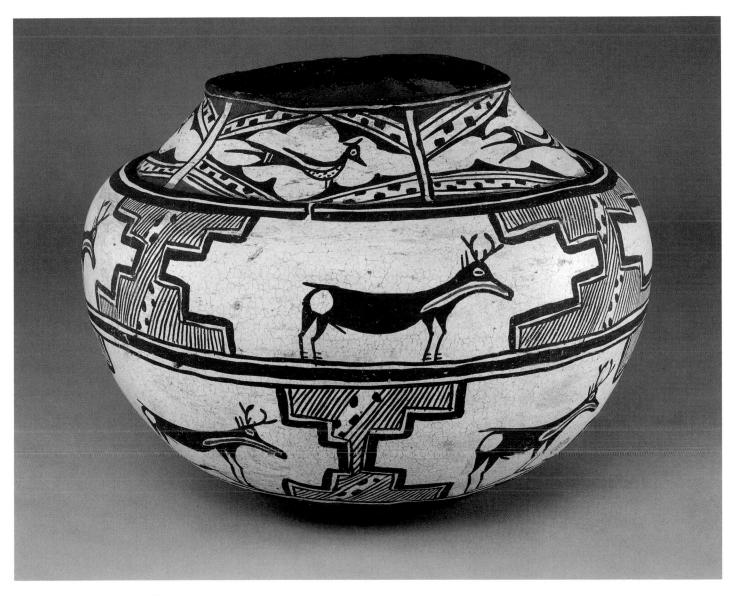

P L A T E 32. JAR (Olla), *Zuni Polychrome, Zuni Pueblo, New Mexico, circa A.D. 1900. Gift of Mrs. Richard W. Meirs in 1918. H. 26.0 D. 34.0 cm (NA 8659). Terraced, "H" shaped dividers frame the spaces in which the animals stand on this painted Zuni jar. The fine-line hachures and vertical zigzags suggest rain and lightning, and the terraces can be interpreted as cloud symbols. (Cat. No. 103)*

FIGURE 27. (Left) *Ladle, Protohistoric Hopi, Jeddito Black-on-yellow. Collected by Stewart Culin from Thomas V. Keam in 1901. (Cat. No. 50)*

FIGURE 28. (Right) *Jar (Olla), Protohistoric Hopi, Jeddito Black-on-yellow. Collected by Stewart Culin from Thomas V. Keam in 1901. (Cat. No. 51)*

prehistoric wares. He described the provenience of these finds in a letter to Culin as follows:

> [E]xhumed from burial places, sacrificial caverns, and ruins: also from sand dunes, near old trails, and the large casks were probably used as storage vessels for water over day routes (Keam to Culin).

Exact proveniences for each piece were not mentioned. Two bowls (Cat. Nos. 48 and 52), a ladle (Cat. No. 50, Fig. 27), and a small jar (Cat. No. 51, Fig. 28) collected by Keam are included in this catalogue (Figs. 27 and 28).

Other dealers provided Culin with more detailed documentation. One of these, the Reverend Heinrich R. Voth, who established the first Mennonite mission at the Hopi village of Oraibi in 1893, was well-known for his careful attention to accuracy and detail in his collecting of Hopi ethnographic materials. Much of our anthropological knowledge of nineteenth-century Hopi social and ceremonial life comes from Voth's notes and published articles (Cat. No. 53 was collected by Voth).

One of the problems that consistently plagued collectors was transportation of the southwestern materials back to sponsoring museums in the East (Parezo 1987:16). Culin was no exception. While trying to arrange for the shipment of materials from Holbrook, Arizona, Culin ran into problems with the Atchison, Topeka and Santa Fe Railway. It was

necessary for trains from the Southwest to pass through Chicago enroute to Philadelphia. In Chicago all freight was opened, inspected, and then repacked. Culin, in a series of correspondence, successfully stopped the unnecessary handling. By the end of December, 1901, the collection reached Philadelphia, where it was exhibited at the Museum in 1902, with pieces from the Donaldson collection.

THE GOTTSCHALL COLLECTION

Another collection, assembled by Amos H. Gottschall between 1871–1905, did not come to The University Museum until well into the twentieth century. Gottschall, a Pennsylvania native, traveled in the West making his living as a peddler of patent medicines and assembling collections of Indian artifacts. In 1937 the Academy of Natural Sciences of Philadelphia transferred its Gottschall collection of southwestern pottery to The University Museum "on permanent loan." Gottschall assigned the Indian artifacts he collected to one of three different categories—in the first two groups he intended to represent the choicest materials available.

> Collection No. 1 . . . is a typical and representative collection, very desirable and appropriate as a Private Collection for an Advanced Collector, or Connoisseur, or as a Museum Display. The specimens were gleaned with much care, and are the very cream of their kind. Concerning Collection No. 2 . . . the same may be said in every particular . . . [but] is not so large, and not quite so fine as Collection No. 1 (Gottschall 1909, Notice).

The Academy purchased both these collections. A third collection was created to serve as a basis for a business of artifact trading. Gottschall had hoped his son would use this collection to establish himself as a businessman, but unfortunately the son died before this could happen. Gottschall describes the third collection as "vast bulk stock." This third part The University Museum purchased in 1942 from Ira Reed, a Philadelphia dealer who acquired it from Gottschall in 1939. The choicest specimens went into the Museum's collection, and the remainder was sold at The Museum's sales shop.

What makes the Gottschall collection particularly interesting and useful to researchers is the catalogue that Gottschall himself wrote as an advertisement to attract purchasers (Fig. 29). In the catalogue he describes his experience in the pueblos of New Mexico and Arizona, and the Pueblo women's perplexity as to why this non-Indian man would want some of their wares.

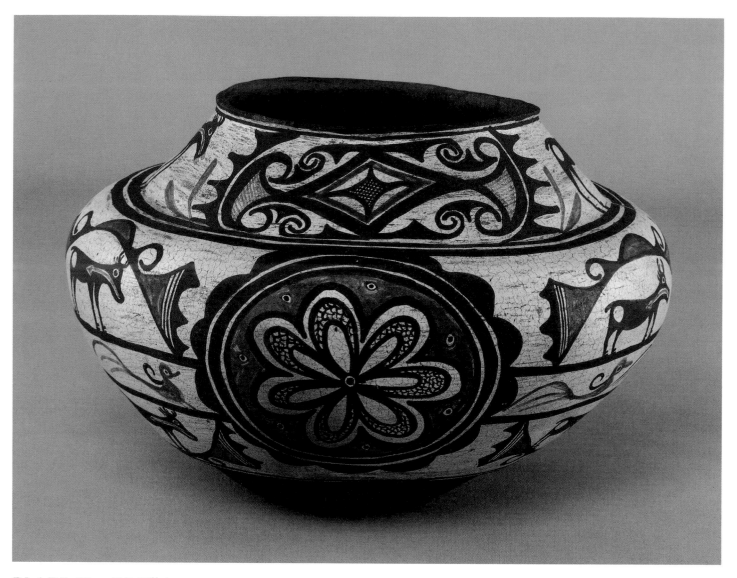

PLATE 33. JAR (Olla), *Zuni Polychrome, Zuni Pueblo, New Mexico, circa A.D. 1880–1890. Collected by William H. Bean of the U.S. Army Border Commission and donated by Mrs. V. Downing. H. 23.0 D. 36.0 cm (58-14-1). The frame above each deer depicted on this jar is referred to by potters as a "house." The deer stand on ground lines, and the four registers suggest stages of the mythical journey through the Underworld. The rosettes on the upper register, called "sunflowers," are interpreted as sun symbols. (Cat. No. 98)*

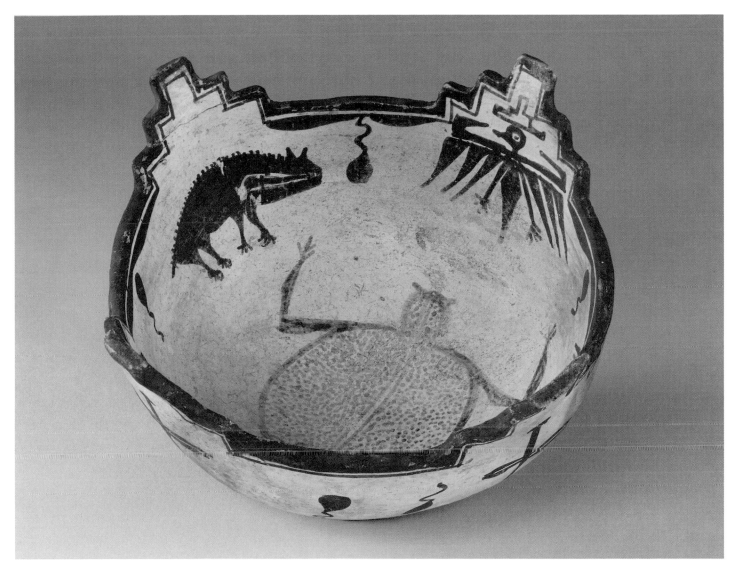

PLATE 34. TERRACED BOWL, *Zuni Polychrome, Zuni Pueblo, New Mexico, circa A.D. 1880–1890. Donated by Haverford College, Haverford, Pennsylvania, 1961. H. 13.0 D. 23.0 cm (61-34-3). At Zuni Pueblo cornmeal is offered with prayers both daily and on special occasions. After 1850 Zuni people often kept cornmeal available in bowls made for that purpose, and "prayer bowls" soon became popular curios. Isolated depictions of water-animals and other water symbols, including clouds, rain and lightning, are often painted on bowls of this kind as are prey animals associated with hunting. (Cat. No. 99)*

Typical Collection No. 1.

Priced and Descriptive Catalogue

OF THE

Utensils, Implements, Weapons, Ornaments, Etc.,

OF THE

Indians, Mound Builders, Cliff Dwellers.

Collected by

A. H. GOTTSCHALL,

During the years 1871 to 1905,—a period of 34 years.

This collection is now offered for sale.

ADDRESS,

A. H. GOTTSCHALL,
250 HUMMEL ST.,
HARRISBURG, PENNA.,
1909

FIGURE 29. *Cover of A.H. Gottschall sale catalogue. (neg. S4-139878)*

As to what use I could possibly make of such old wares and trinkets, was a mystery to the Indians, and I was often an object of peculiar looks and smiles. But so long as they could get a valuable return for some old implement or trinket that had probably lain idle and discarded for centuries, they were interested (Gottschall 1909, No. 1:4).

Gottschall was very careful to record the specific place from which he acquired each object. He indicated the village name if the artifacts were historic. The provenience for the prehistoric materials could not be as precisely determined and is usually limited to a general region of a state, such as southwestern Colorado. In his catalogue Gottschall also indicated the price at which he was prepared to sell each piece. While this does not tell us what he paid for the objects, it does provide the going rate for Indian artifacts in 1909. His descriptions and prices for four items in The University Museum's collection (Cat. Nos. 68, 79, and 102) are indicative of his presentation.

Clay bowl, decorated in colored designs, Zuni Pueblo, near Zuni River, N. Mex. $2.25
Clay olio, Acoma Pueblo, N. Mex. $2.25
Clay Tablet, Moqui [Hopi] Pueblo, Ariz. $1.75
Clay Tablet, Moqui [Hopi] Pueblo, Ariz. $1.75

(Gottschall 1909, No. 1:28)

As a result of Gottschall's eclectic collecting methods, his collection contains some of the Museum's finest traditional pieces of pottery, along with much pottery influenced by and created for sale to tourists in the early years of this century.

THE STEPHENS COLLECTION

The last large collection of southwestern pottery to be acquired by The University Museum was purchased in 1945 from the family of Charles H. Stephens. Stephens, a Philadelphia commercial artist, made his living by illustrating books and articles on American history and American Indians. He was fascinated by Indians and their cultures and spent much time traveling and collecting ethnographic materials from diverse Indian groups—including the Blackfeet, Seminole, Ute, Osage, and the Pueblos. He was careful to record information about where he acquired each piece although the year each piece

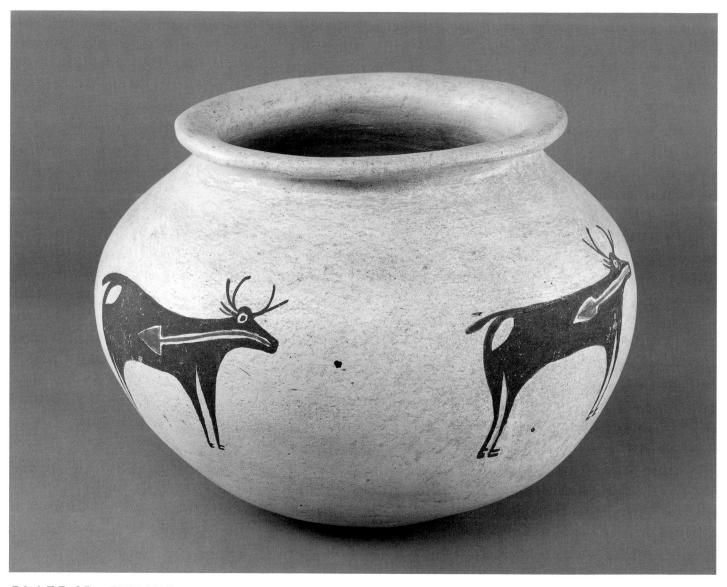

PLATE 35. DRUM JAR, *Zuni Polychrome, Zuni Pueblo, New Mexico, circa A.D. 1930. Gift of Mrs. D.K. Lower, 1976. H. 24.0 D. 35.0 cm (76-24-1). Drum jars used in ritual are partly filled with water and covered with buckskin. The drum-stick is curved and resembles a prayer-stick or rainbird motif. Similar paintings of deer were recorded in the nineteenth century on the walls of religious society rooms at Hopi villages and at Zuni Pueblo. (Cat. No. 104)*

was collected was not recorded. According to his son, Stephens acquired most of his Indian collections in the 1880s (Stephens to Kimball). The pieces selected by Stephens are some of the finest in the Museum.

CONCLUSION

Over the years generous donors have given their personal collections of southwestern pottery to the Museum. The pieces were often acquired by the donors as a reminder of their trip to the Southwest. Ceremonial pottery made especially popular collectibles. At times a fabricated connection to the Indians' religious life was provided by dealers to justify an increase in the price of the specimens. The documentation accompanying these individual gifts varies from donor to donor. Some collectors were uncertain where the objects were acquired or had only vague recollections. In some cases the approximate provenience and date of manufacture can be determined solely on the basis of stylistic analysis. The gifts are valuable supplements to the large early collections. Taken as a whole, the southwestern pottery collection of The University Museum is an excellent resource, documenting the history of the Pueblo people as illustrated through the craft they practiced.

ACKNOWLEDGMENTS

Many thanks go to Jerry Brody for giving me the opportunity to write this article. A number of people made useful comments on the various versions: Jean Adelman, Catherine Ambrose, Pamela Hearne, Lee Horne, Donald Laird, Nancy Parezo, Karen Vellucci, and Lucy Fowler Williams. Douglas Haller, Alessandro Pezzati, and Colin Varga of The University Museum Archives provided helpful assistance and access to the documents and photographs.

REFERENCES

Babcock, Barbara A., Monthan, Guy and Doris Monthan
1986 *The Pueblo Storyteller: Development of a Figurative Ceramic Tradition.* Tucson: University of Arizona Press.

Brody, J.J.
1977 "Pueblo Fine Arts." In *Handbook of North American Indians,* Vol. 9, *The Southwest,* ed. Alfonso Ortiz, pp. 603–608. Washington, D.C.: Smithsonian Institution.

Donaldson, Thomas C.
1893 "Moqui Pueblo Indians of Arizona and Pueblo Indians of New Mexico." *Eleventh Census of the United States.* Washington, D.C.: United States Census Printing Office.

Gottschall, A.H.
1909 *Priced and Descriptive Catalogue of the Utensils, Implements, Weapons, Ornaments, Etc. of the Indians, Mound Builders, Cliff Dwellers,* Typical Collection No. 1, No. 2 and No. 3 and Notice. Harrisburg: privately printed.

Green, Reverend C.H.
1893 *Catalogue of Unique Collection of Cliff Dweller Relics.* Chicago: privately printed for exhibit at Art Institute of Chicago.

Lister, Robert H., and Florence C. Lister
1985 "The Wetherills: Vandals, Pothunters, or Archaeologists." In Nancy C. Fox, ed. *Prehistory and History of the Southwest: Papers in Honor of Alden C. Hayes,* pp. 147–153. Albuquerque: Archaeological Society of New Mexico.

McNitt, Frank
1957 *Richard Wetherill: Anasazi.* Albuquerque: University of New Mexico Press.

Parezo, Nancy J.
1987 "The Formation of Ethnographic Collections: The Smithsonian Institution in the American Southwest." In M.B. Schiffer, ed., *Advances in Archaeological Method and Theory,* vol. 10, pp. 1–47. Orlando, FL: Academic Press.

Philadelphia Record
1895 "With Western Mummies: a Glimpse of Some of the Wonders of Cliff Dwellers' Relics." November 10.

Philadelphia Times
1895 "Primitive Civilizations: The Great Exhibition at the University of Pennsylvania and
 Its Wonderful Light on the Past." November 10.

Smith Exploring Company, H. Jay
1893 *The Cliff Dwellers.* Chicago: privately printed for World's Columbian Exposition.

Documents from The University Museum Archives, University of Pennsylvania.
Curatorial Records––American Section––Collectors and Collections Series.

"Agreement between Mr. C.D. Hazzard of Minneapolis, Minnesota, and the Department of
 Archaeology of the University of Pennsylvania," 29 March 1895.

Alliot, Hector to Stewart Culin, Los Angeles, 14 May 1895.

Culin, Stewart to Robert C.H. Brock, Philadelphia, 3 April 1900.

Culin, Stewart to Robert C.H. Brock, Philadelphia, 16 April 1901.

Cushing, Frank Hamilton to Stewart Culin, Washington, D.C., 29 October 1895.

Donaldson, Thomas B. to Stewart Culin, Philadelphia, 24 April 1901.

Hearst, Mrs. Phoebe, letter, Washington, D.C., 22 January 1896.

Keam, Thomas V. to Stewart Culin, Keam's Canon, AZ, 20 October 1901.

Stephens, D. Owen to Fiske Kimball, Philadelphia, 30 November 1931.

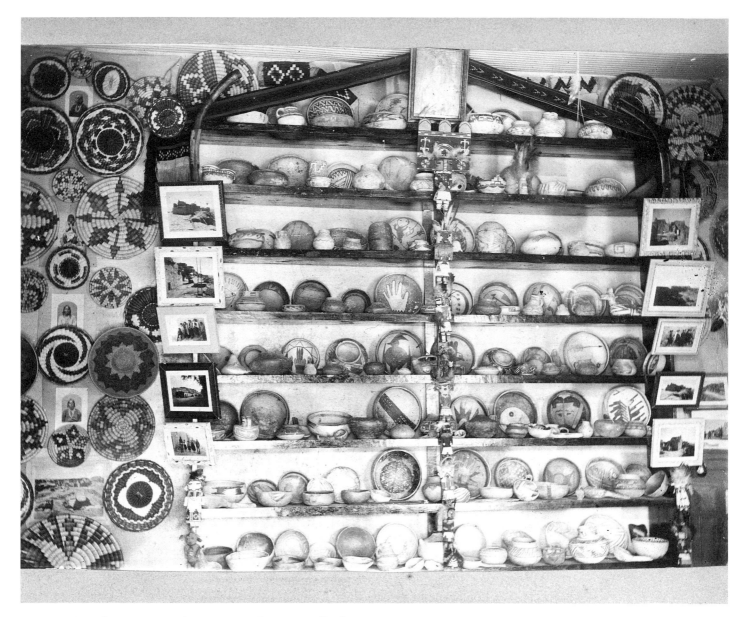

FIGURE 30. *Thomas Keam's curio room, circa 1901, displaying protohistoric Hopi and prehistoric pottery. Cat. No. 52 is displayed on the seventh shelf from the top, directly to the right of center. (neg. S4-139897)*

CATALOGUE
COMPENDIUM

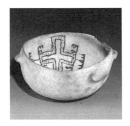

1. BOWL, ANASAZI
 Kana-a Black-on-white.
 Circa A.D. 725–775.
 Collected by Stewart Culin on the
 Wanamaker Expedition of 1901.
 H. 8.0 D. 16.5 cm. (29–77–763).

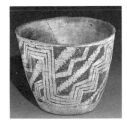

2. BOWL, ANASAZI
 Kana-a Black-on-white.
 Circa A.D. 800–875.
 Collected by Stewart Culin on the
 Wanamaker Expedition of 1901.
 H. 12.0 D. 14.0 cm. (29–77–221).

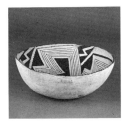

3. BOWL, ANASAZI
 Red Mesa Black-on-white.
 Circa A.D. 870–950.
 Collected by Stewart Culin on the
 Wanamaker Expedition of 1901.
 H. 8.0 D. 21.0 cm. (29–77–422).

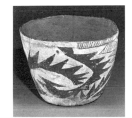

4. BOWL, ANASAZI
 Puerco Black-on-white.
 Circa A.D. 950–1100.
 Collected by Stewart Culin on the
 Wanamaker Expedition of 1901.
 H. 14.0 D. 18.0 cm. (29–77–222).

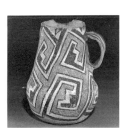

5. PITCHER, ANASAZI
 Gallup Black-on-white.
 Circa A.D. 950–1100.
 Collected by Stewart Culin on the
 Wanamaker Expedition of 1901.
 H. 20.2 D. 14.0 cm. (29–77–497).

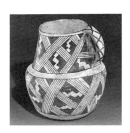

6. PITCHER, ANASAZI
 Puerco Black-on-white.
 Circa A.D. 950–1100.
 Collected by Stewart Culin on the
 Wanamaker Expedition of 1901.
 H. 19.0 D. 16.0 cm. (29–77–562).

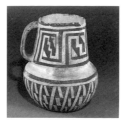

7. PITCHER, ANASAZI
Puerco Black-on-white.
Circa A.D. 950–1100.
Collected by Stewart Culin on the
Wanamaker Expedition of 1901.
H. 18.0 D. 15.0 cm. (29–77–564).

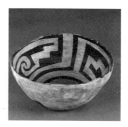

8. BOWL, ANASAZI
Puerco Black-on-white.
Circa A.D. 950–1100.
Collected by Stewart Culin on the
Wanamaker Expedition of 1901.
H. 9.5 D. 20.0 cm. (29–77–643).

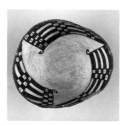

9. BOWL, ANASAZI
Reserve Black-on-white.
Circa A.D. 950–1100.
Collected by Stewart Culin on the
Wanamaker Expedition of 1901.
H. 9.0 D. 15.0 cm. (29–78–424).

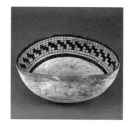

10. BOWL, ANASAZI
Reserve Black-on-white.
Circa A.D. 950–1100.
Collected by Stewart Culin on the
Wanamaker Expedition of 1901.
H. 12.5 D. 27.0 cm. (29–78–481).

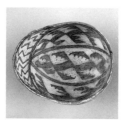

11. SCOOP, ANASAZI
Mancos Black-on-white.
Circa A.D. 950–1150.
Collected by Stewart Culin on the
Wanamaker Expedition of 1901.
H. 9.0 D. 15.0 cm. (29–77–657).

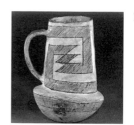

12. PITCHER, ANASAZI
Chaco Black-on-white.
Circa A.D. 1050–1125.
Collected by Stewart Culin on the
Wanamaker Expedition of 1901.
H. 18.0 D. 13.0 cm. (29–77–750).

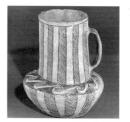

13. PITCHER, ANASAZI
Gallup Black-on-white.
Circa A.D. 1050–1150.
Collected by Stewart Culin on the
Wanamaker Expedition of 1901.
H. 20.0 D. 14.5 cm. (29–78-211).

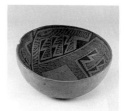

14. BOWL, ANASAZI
Wingate Black-on-red.
Circa A.D. 1050–1200.
Collected by Stewart Culin on the
Wanamaker Expedition of 1901.
H. 11.0 D. 26.2 cm. (29–77–599).

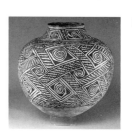

15. JAR (Olla), ANASAZI
Walnut Black-on-white.
Circa A.D. 1100–1125.
Collected by Stewart Culin on the
Wanamaker Expedition of 1901.
H. 43.0 D. 44.0 cm. (29–77–686).

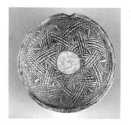

16. BOWL, ANASAZI
Flagstaff Black-on-white.
Circa A.D. 1100–1200.
Collected by Stewart Culin on the
Wanamaker Expedition of 1901.
H. 12.0 D. 23.5 cm. (29–77–598).

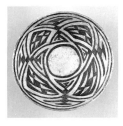

17. BOWL, ANASAZI
Flagstaff Black-on-white.
Circa A.D. 1100–1200.
Collected by Stewart Culin on the
Wanamaker Expedition of 1901.
H. 11.0 D. 23.5 cm. (29–77–761).

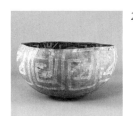

22. BOWL, ANASAZI
St. Johns Polychrome.
Circa A.D. 1175–1300.
Collected by Stewart Culin on the
Wanamaker Expedition of 1901.
H. 17.0 D. 31.0 cm. (29–77–230).

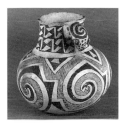

18. LADLE, ANASAZI
Tularosa Black-on-white.
Circa A.D. 1100–1250.
Collector unknown.
H. 8.5 L. 29.5 W. 14.2 cm.
(NA 2202).

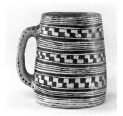

23. BOWL, ANASAZI
St. Johns Polychrome.
Circa A.D. 1175–1300.
Collected by Stewart Culin on the
Wanamaker Expedition of 1901.
H. 15.0 D. 31.5 cm. (29–78–783).

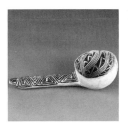

19. PITCHER, ANASAZI
Tularosa Black-on-white.
Circa A.D. 1100–1250.
Collected by Stewart Culin on the
Wanamaker Expedition of 1901.
H. 17.5 D. 17.0 cm. (29–77–502).

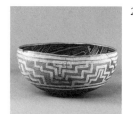

24. MUG, ANASAZI
Mesa Verde Black-on-white.
Circa A.D. 1200–1300.
Acquired by Robert K. McNeely from the
Wetherill brothers in 1893 and donated
to the Museum in 1895.
H. 12.7 D. 13.0 cm. (13002).

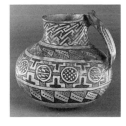

20. PITCHER, ANASAZI
Tularosa Black-on-white.
Circa A.D. 1100–1250.
Collected by Stewart Culin on the
Wanamaker Expedition of 1901.
H. 18.0 D. 17.0 cm. (29–77–616).

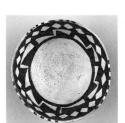

25. BOWL, ANASAZI
Mesa Verde Black-on-white.
Circa A.D. 1200–1300.
Purchased in 1896 with funds provided
by Mrs. Phoebe A. Hearst.
H. 9.0 D. 18.2 cm. (22937).

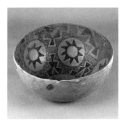

21. BOWL, ANASAZI
Wingate Black-on-red, Tularosa style.
Circa A.D. 1175–1225.
Collected by Stewart Culin on the
Wanamaker Expedition of 1901.
H. 14.0 D. 28.0 cm. (29–78–470).

26. BOWL, ANASAZI
Mesa Verde Black-on-white.
Circa A.D. 1200–1300.
Purchased in 1896 with funds provided
by Mrs. Phoebe A. Hearst.
H. 14.0 D. 28.0 cm. (22967).

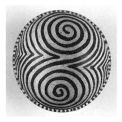

27. BOWL, ANASAZI
Mesa Verde Black-on-white.
Circa A.D. 1200–1300.
Purchased in 1896 with funds provided
by Mrs. Phoebe A. Hearst.
H. 9.0 D. 19.0 cm. (22976).

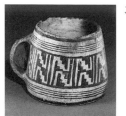

32. MUG, ANASAZI
Mesa Verde Black-on-white.
Circa A.D. 1200–1300.
Purchased in 1896 with funds provided
by Mrs. Phoebe A. Hearst.
H. 9.0 D. 12.5 cm. (23036).

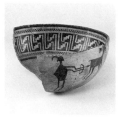

28. BOWL FRAGMENT, ANASAZI
Mesa Verde Black-on-white.
Circa A.D. 1200–1300.
Purchased in 1896 with funds provided
by Mrs. Phoebe A. Hearst.
H. 15.0 D. 28.2 cm. (22982).

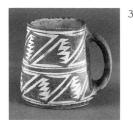

33. MUG, ANASAZI
Mesa Verde Black-on-white.
Circa A.D. 1200–1300.
Purchased in 1896 with funds provided
by Mrs. Phoebe A. Hearst.
H. 11.2 D. 12.0 cm. (23043).

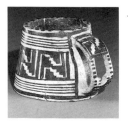

29. MUG, ANASAZI
Mesa Verde Black-on-white.
Circa A.D. 1200–1300.
Purchased in 1896 with funds provided
by Mrs. Phoebe A. Hearst.
H. 9.5 D. 13.5 cm. (23030).

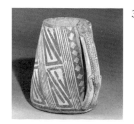

34. MUG, ANASAZI
Mesa Verde Black-on-white.
Circa A.D. 1200–1300.
Purchased in 1896 with funds provided
by Mrs. Phoebe A. Hearst.
H. 17.0 D. 15.0 cm. (23049).

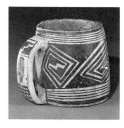

30. MUG, ANASAZI
Mesa Verde Black-on-white.
Circa A.D. 1200–1300.
Purchased in 1896 with funds provided
by Mrs. Phoebe A. Hearst.
H. 11.0 D. 13.0 cm. (23031).

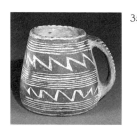

35. MUG, ANASAZI
Mesa Verde Black-on-white.
Circa A.D. 1200–1300.
Purchased in 1896 with funds provided
by Mrs. Phoebe A. Hearst.
H. 12.0 D. 14.5 cm. (23052).

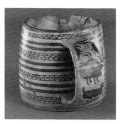

31. MUG, ANASAZI
Mesa Verde Black-on-white.
Circa A.D. 1200–1300.
Purchased in 1896 with funds provided
by Mrs. Phoebe A. Hearst.
H. 11.5 D. 15.0 cm. (23035).

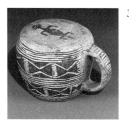

36. MUG, ANASAZI
Mesa Verde Black-on-white.
Circa A.D. 1200–1300.
Purchased in 1896 with funds provided
by Mrs. Phoebe A. Hearst.
H. 7.8 D. 11.0 cm. (23057).